lighting | for food and drink
photography

Steve Bavister

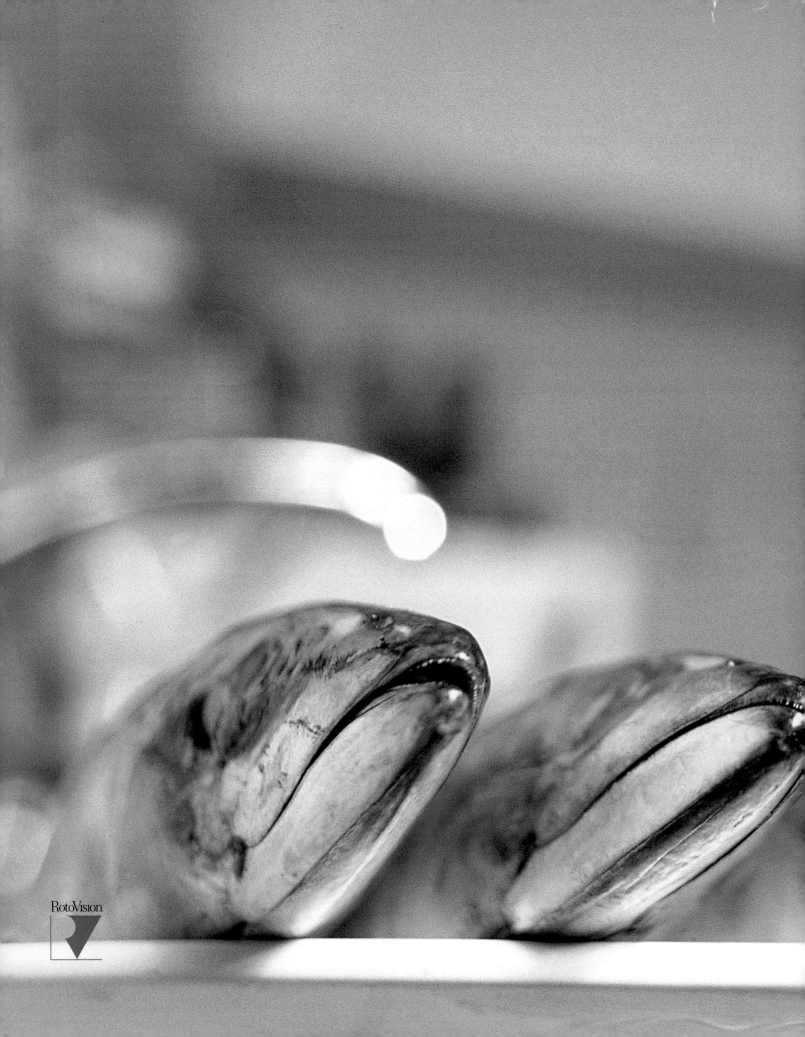

lighting | for food and drink
photography

Steve Bavister

A RotoVision Book
Published and distributed by
RotoVision SA

RotoVision SA, Sales, Production & Editorial Office
Sheridan House, 112/116A Western Road
Hove, East Sussex BN3 1DD, UK

Tel: +44 (0)1273 72 72 68
Fax: +44 (0)1273 72 72 69
E-mail: sales@rotovision.com
Website: www.rotovision.com

ISBN 2–88046–570–2

10 9 8 7 6 5 4 3 2 1

Book design by Red Design

Production and separations in Singapore by
ProVision Pte. Ltd.

Tel: +65 334 7720
Fax: +65 334 7721

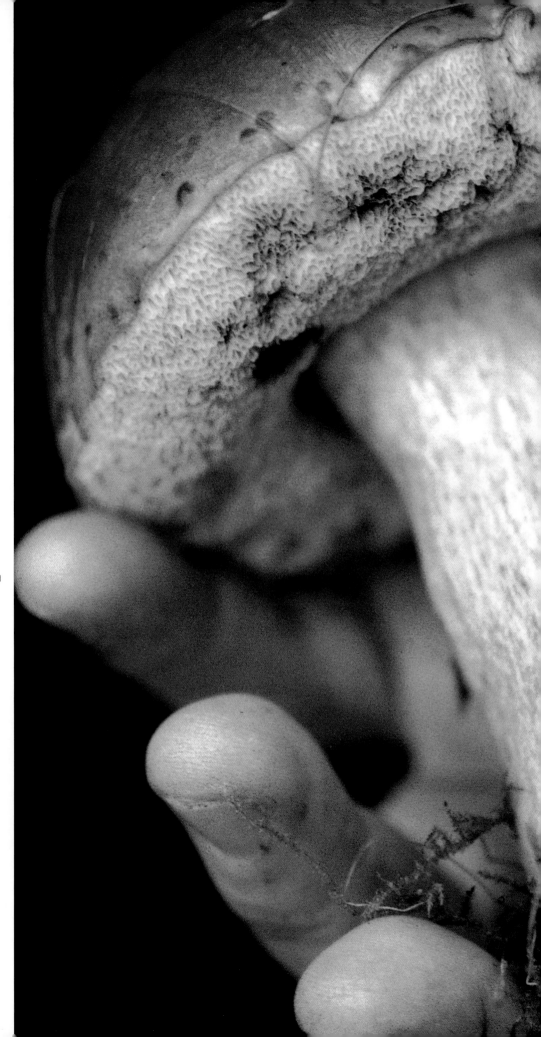

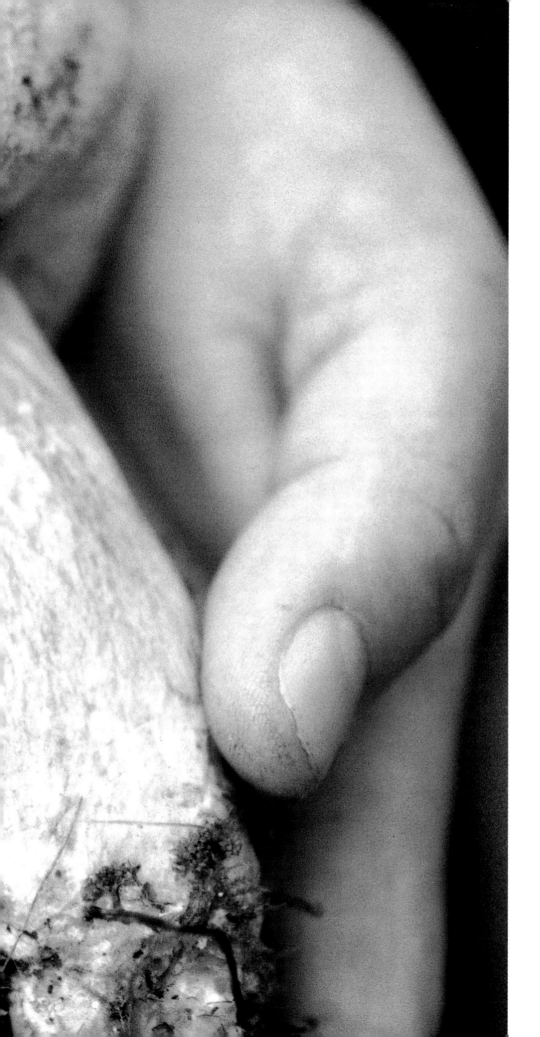

contents

6: Introduction

lighting... for food and drink photography
the food and drink market
talents required
lighting issues
equipment matters
working together

10: styling for food and drink
home economist Janice Murphitt
food stylist Mikael Beckman

14: making light work
more doesn't mean better
controlling the contrast
light isn't white
daylight moods
studio control
which lights when?
accessories that assist
measure for measure

18: glossary of lighting terms

21: practicalities
understanding the lighting diagrams

22: daylight / ambient

36: a single source

70: two lights

114: sophisticated set-ups

152: directory

160: acknowledgements

lighting...

Whether you developed your photographic lighting skills by going to college, watching master photographers at work, from reading books and magazines, or simply through trial and error, you will by now have built up a solid repertoire of techniques that you come back to time and again. But endlessly recycling your set-ups quickly becomes boring and repetitive – not only for you, but also for your clients. What's more, styles of lighting change over time, and without realising it you can suddenly find your work looking dated – and neither successful nor saleable. Given that lighting is arguably the single most important element in any photograph, it's essential to keep up with contemporary trends.

That's where RotoVision's LIGHTING... series of books comes in. Each title features a selection of cutting-edge images from leading exponents in that particular field who have been persuaded to share their lighting secrets with the world at large. In most cases we have talked to the photographer at length to find out exactly where everything was positioned and why one kind of accessory was used rather than another. At the same time we picked up lots of useful general hints and tips which have also been included.

Some of the images rely just upon daylight; in others, ambient illumination is combined with flash or tungsten lighting; and some feature advanced multi-head arrangements. As a result the LIGHTING... series provides a wonderfully rich smorgasbord of information which would be impossible for you to get any other way. It's like standing in the studios of some of the world's

most successful image-makers and watching them at work. Each self-contained two- or four-page section focuses on an individual shoot or looks at the approach of a particular photographer in more depth. Three-dimensional lighting diagrams show you the set-up at a glance – allowing you to replicate it for your own use – while the commentary explains in detail what was involved. Whenever possible we have also included additional images that were either taken at the same time or using the same technique, or illustrating an alternative treatment.

Who will find this book useful? Anyone looking to improve their photography, whether it be for pleasure or profit. Professionals, or anyone looking to make the move from amateur to professional, will find it an invaluable source of

inspiration to spice up their own image-making. It doesn't matter how much experience we have as photographers – there's always something new to learn. Any of the photographs here could help kick-start the engine of your imagination and get your creative juices flowing in a new direction.

Alternatively, you may be looking to solve a particular picture-taking problem. You've got a job to do and you're not sure what would be the best approach. Or you've run short of ideas and want to try out some new techniques. If so, simply flip through the pages until you come across an image that has the kind of feel or look you're after and then find out how it was created.

Art directors, too, will find each title in the series an invaluable primer on contemporary styles as

well as a source for new photographic talent. Ultimately, though, LIGHTING... will appeal to anyone who loves looking at great pictures and wants to enjoy them for their own sake, with no other motive in mind.

It's ironic that, at a time when people in developed countries increasingly buy their food in a prepared, processed form, ready to pop in the microwave or oven, interest in food has never been greater – as the proliferation of television programmes, best-selling books and magazine articles on the subject shows. Naturally this booming market provides opportunities for photographers either working in this area or looking to move into it. Never has there been more demand for high-quality images of food and drink.

the food and drink market

Food packaging is one obvious area of growth. In the days when people prepared meals from scratch they bought the ingredients themselves – potatoes, onions, chicken, rhubarb. Such things didn't need photographing, because you could see what they were, and hold them in your hand. With ready-to-cook meals that's not the case. Photographs are required on the box to show you what it will look like once it's been heated and served. With hundreds of different brands and thousands of different products, this multi-billion-pound industry has a voracious appetite for creative packaging images.

Of course, consumers cannot be expected simply to discover new lines in the shops. They must be encouraged to look for them through advertising – one of the most lucrative areas of food and drink photography to get into. With the enormous price of a page in a quality publication, and a poster site costing a small fortune, the fees paid to photographers seem relatively small to the companies involved. Specialist food magazines aside (of which there are an increasing number), food and drink coverage is an essential part of the mix provided by many of the mass circulation magazines aimed at women. The next time you're in a store selling a wide range of magazines, just spend a few minutes flipping through a selection and discovering how many pages are devoted to the subject, and how many images are used as illustration. Most newspapers also feature food and drink on a regular basis. And that's without considering the hundreds of dedicated food books published each year. How can you take a slice of this lucrative pie? Well, not surprisingly the competition for glamorous and well-paid work of this kind is cut-throat, so you'll need a decent portfolio of images to even get your foot in the door. The good news is that the barriers to entry are low, and getting started couldn't be easier. Simply stop by your local supermarket, buy a selection of produce, and you're on your way.

One good way of building up your skills and marketability whilst earning a return is to become a contributor to one of the photo libraries specialising in food and drink photography. Providing they feel you have the required talent, they will normally be willing to provide you with details of their current 'wants' and give you feedback should your initial efforts fall slightly short of the mark. When you set your sights higher, and start thinking about shooting cooked food, you will probably find a friend or family member who's handy in the kitchen to prepare it attractively for you. Then, once you begin to get established, you can afford to start hiring home economists and stylists as necessary to fulfil your commissions.

talents required

Food and drink photography is essentially a specialised area of still-life photography. One of the key skills is patience – the ability to work painstakingly at putting together the perfect shot. As you're working with such a small canvas, you need to pay careful attention to detail, and be meticulously clean, as crockery and silverware will show every fingerprint and speck of dust. You'll also need to be sufficiently obsessive to want to sort through a dozen punnets of strawberries to find the three fruits that have the best shape. Naturally, you'll have to be creative, as you'll find yourself faced with the same subject time and again and be expected to come up with something that's new and exciting.

Like all areas of photography, food and drink is subject to fashions and trends. Right now the most common style features an extremely narrow zone of focus, with just a tiny part of the subject sharp and the rest blurring into the background. It's essential to keep up-to-date with what's new, and the best way to do that is to subscribe to magazines that feature cutting-edge food image-making.

lighting issues

You'll need to be imaginative with your lighting, adapting it to the needs of the subject and the requirements of the client. Daylight is occasionally used, but more often it is studio lighting arranged to create pseudo-daylight effects. Most practitioners seem to go for electronic flash, with only a handful choosing tungsten sources – although these are seeing a resurgence in the shape of the continuous HMI sources used for digital capture. As long as care is taken with subjects that might wilt or melt – such as salads and ice cream – the heat generated by tungsten heads or flash modelling lights presents no real problem, though it makes sense to switch them off when not in use.

As often as not, the lighting required is soft and shadowless, and for that reason heads are often directed through purpose-made trace screens which can be moved closer to or further away from the subject or light, giving a high degree of control over the resulting illumination. Black card scrims or flags are also widely used to block off excess light falling onto or around the subject.

Often just one light is used, perhaps with reflectors. If screens are not being used then a softbox will usually be fitted to diffuse the output. With textured subjects such as biscuits, backlighting is commonly employed, with a light pointing back towards the camera, sometimes supplemented by a fill light overhead and/or a lower-powered head facing it.

Because sets are mostly small, many practitioners use lots of little reflectors and mirrors to lighten shadow areas and place highlights where they are wanted. These are often held in place by clamps – except for shaving mirrors, which can be swivelled to direct light where required.

equipment matters

The enormous improvements in film quality over recent years have resulted in many professional areas of photography moving to roll-film cameras from large-format. Apart from a handful of exceptions, however, that's not true of food and drink photography, where 5 x 4 inch and 10 x 8 inch models continue to rule the roost. There are two main reasons for this: first, because maximum detail and clarity are required by clients, and second, because movements are usually necessary for controlling perspective and depth-of-field. Lenses tend to be standard or slightly telephoto focal lengths – with wide-angles rarely used except where more of the background is included. Longer telephotos are used where it's not possible to move the camera closer.

The static nature of subjects such as food and drink make them ideal for high-quality digital capture, so it's no surprise that an increasing number of photographers working in this area are now using digital backs instead of film. The benefits are obvious: you can see the results immediately, and move onto the next shot with confidence; you eliminate the cost of materials and processing; and the client doesn't need to have the image scanned. Film, though, retains a loyal following – and since most images are shot for publication, it's transparency emulsions that are generally used. With its vivid colours and biting sharpness, Velvia is a popular choice – but other slide films from Fuji and Kodak with ratings up to ISO 100 are widely employed. Most food and drink studios also have a stock of Polaroid materials to check on the exposure, lighting and composition.

working together

Sometimes food and drink photographers will find themselves working alone, but this is the exception rather than the rule, and most likely when the subject is a relatively simple still-life composed of raw ingredients or bottles and glasses. Once the shot becomes more sophisticated, and includes food which has to be cooked or prepared, then more often than not the studio will be buzzing with possibly a home economist or chef, a stylist, an art director, set builders and any assistants. Having many creative individuals working together in what is often a pressurised environment could be a recipe for conflict and friction, but generally shoots are good-natured affairs with each person being allowed to make contributions according to their area of expertise.

... for food and drink photography

styling for food and drink
home economist Janice Murphitt

What can home economists contribute to a food shoot – and are they essential?

They can make an enormous difference to the quality and style of the finished pictures. Usually they will have studied food technology, nutrition and development, and will know how to prepare, cook and present food so it looks as attractive and appealing as possible. However, if it's a still-life food shot, using raw ingredients such as fruit or vegetables, it may not make sense to have a home economist present all the way through the shoot. Instead you could ask them to shop for you – to go out and get the best possible examples of the foods you're using – perhaps with accompanying leaf stems etc. to make it more interesting. If there's anything that needs to be cooked or made, it's worth investing in the skills and experience of a home economist, who will have an awareness of how things look when photographed. They will be thinking about textures and colours and should know many useful techniques for getting the best results.

A cheese wire will cut gateaux more cleanly than a knife. Vegetables should be cooked only briefly, so they have bright colours and clear surfaces. Mixing glycerine with water creates nice droplets instead of just running off. And if you roast a turkey until it's golden brown, as soon as you take it out it shrivels, wrinkles and looks dreadful. But if you cook it for half an hour rather than the full four hours, and then brush over it with Marmite mixture or varnish, you get that wholesome, tasty appearance that is required.

How do home economists work?

It depends upon the job, and sometimes it's not until you get to the studio that you know what you're going to be doing that day. Everyday work is packaging and advertising, where products come to the studio and you have to show such things as a ready meal on a plate, a spoon of yoghurt with a topping, or a pie baked to look really beautiful. You're normally given a tight brief which you have to follow carefully.

With editorial, it's a case of cooking the recipes and then putting them on the plate as attractively as you can. If you haven't written the recipe yourself it will be sent to you, and you shop and prep for the shot, getting all the ingredients beforehand, so you have to spend the minimum time in the studio on each recipe. Sometimes the recipes are unworkable, especially those from leading chefs who have facilities available to them people don't have at home – and you have to figure out how you can make it feasible in a domestic situation. With editorial you've got some leeway, and can add garnishes to improve things, but you must remain true to the written recipe.

Sometimes clients want something special, such as really gorgeous chocolate éclairs of different shapes and sizes, with different types of cream inside. This can take a day of prepping and trying it out. In the studio, I'll often be asked to start by supplying a mock-up so the photographer can check the lighting and arrange the composition. They would normally then do a Polaroid and sometimes a test shot. Once everyone is happy with the results we'll often just go for it, only doing more mock-ups and tests if the set changes dramatically. The most important thing is having the ability to correct things that may be wrong or go wrong. You can't just say 'It won't work', because everyone's looking at you to make it right.

Is there 'creative friction' between the photographer, home economist, stylist and art director?

The home economist works closely with the photographer and any other professionals on the shoot. It's very much teamwork. In my experience there's rarely any conflict. When there's a query on the food and how it should be or look, then it's normally down to the stylist, but it's the photographer, together with the art director if they're present, who has the last word. The whole team has to make sure the shot is a success.

Are food pictures ever faked?

Editorial is never faked. People need to be able to read the recipe and make it for themselves – and the picture must reflect what it will actually look like. One of the advantages of using an experienced home economist is that their extensive knowledge of food enables them to get the best out of it without cheating. In advertising and packaging work faking isn't that common, but with some products it makes things easier.

Ice cream can be a problem – because of the 'melt factor'. If you take a scoop and put it on a cone it looks wonderful – for a few seconds. Some companies are quite happy for you to make up fake ice cream using a sugar paste mixture, which looks absolutely perfect. I was recently asked to help with a shot of yoghurt on a teaspoon being lifted out of the pot, but the yoghurt wouldn't stay on the spoon, it kept running off. In situations like that you have to be able to improvise, while keeping the product the same colour and texture – and I did that by mixing in a little cornflour.

What skills does a home economist need?

A good background in home economics, because you do so often need to draw upon that knowledge, and then lots of practical experience of working with many different foods – so you're aware of the pitfalls and what to do when things go wrong.

You've got to be well-organised. If you're shooting a succession of different meals in the course of a day, you need to prepare and cook them so they're ready when the photographer wants them. It's also important to have plenty of spares in case there's something wrong with the first one, along with component parts such as gravy or vegetables. With pies, I would always cook at least four, plus one that I can break up and take things from. You've also got to be able to plan ahead. You can't just think, 'Today I'm doing a roast turkey', because you might also need stuffing balls, bacon rolls or roasted chestnuts. If you go with nothing, you have nothing to contribute. You have to go equipped.

A home economist also needs lots of stamina and energy, because you're on your feet all day long. You may have been out at six in the morning shopping for the best produce, and it's not unusual to be working well into the evening. Some shoots can last up to 15 days – you need to make sure you don't start to wilt. A good home economist would also never think, 'That will do'. They will always be striving to achieve the best for the client – whatever that takes. If a shot doesn't work, you've got to be ready to start all over again.

A home economist obviously needs to keep up-to-date with food trends and fashions, which can change dramatically – especially now there are so many food programmes on television. And I guess at the end of the day a good home economist will simply have a passion for food.

How do you go about finding a home economist?

In the UK, the Association of Photographers (www.aop.com) lists home economists and stylists. Alternatively, contact an established food photographer and ask if they could recommend someone to you.

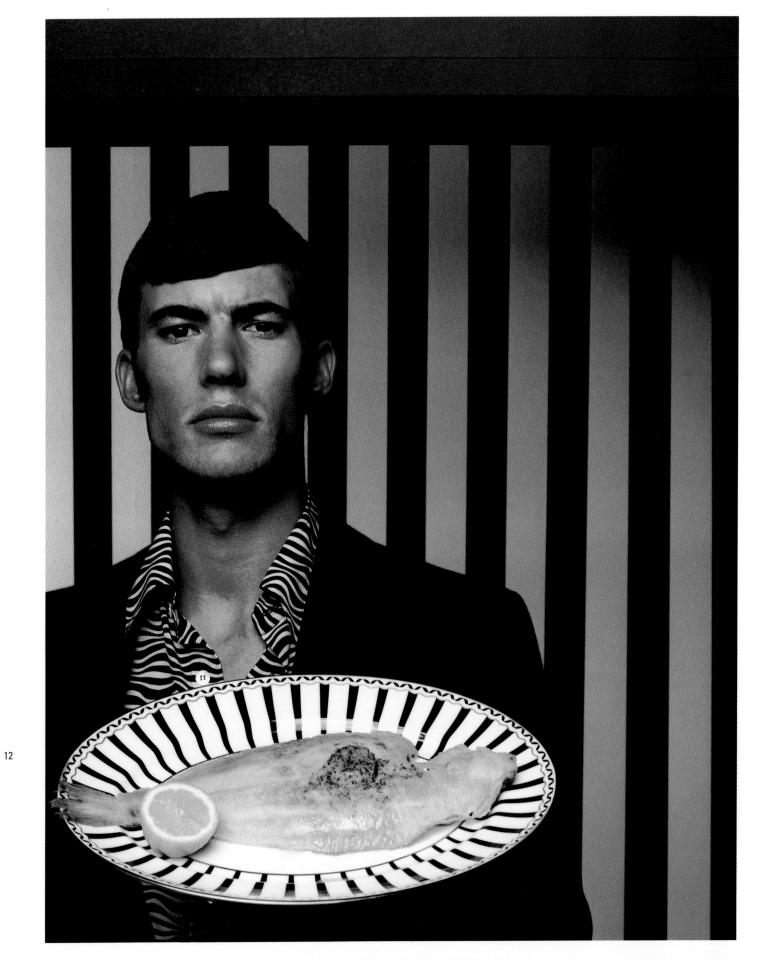

styling for food and drink
food stylist Mikael Beckman

What does a food stylist do?

The stylist will normally be responsible for the overall look and feel of a shot, and will bring in all the props required – such as crockery, glassware, cutlery and little things such as napkins. Sometimes the brief you get from the client or art director is extremely specific. McDonald's, for instance, have a manual, and they know exactly what they want. There will be four to six pieces of onion, a certain number of french fries, and so on. In those cases the styling is a technical rather than a creative exercise.

Often, however, the brief is more open, and the requirement is to create a new look for a product. You don't know at the beginning what the end result will be – it's a journey of discovery for all concerned. Of course, it's not acceptable to create the same thing for different clients. You have to keep coming up with something new, and that's the challenge of being a stylist.

What's your creative process?

The first thing you do is think about the product – who will buy it and why. You do some research and some analysis. It's important to know as much as possible about the customer: whether it's a man or a woman; what age range they are in; what their economic circumstances are. Then there's the question of what the client is trying to achieve? Is it to educate? To create a feeling? To encourage sampling? Then, once I have the look in my mind, I can go out and start looking for all the props I need.

Where do you get props from?

Over the years I've built up a collection of things which I know from experience work well – and that will be true of many stylists. I have over 20 different plates, for instance, all different designs – though most of them are white. Undecorated plates help the food stand out, making it look fresher and tastier. Darker plates can easily kill the look of the food. Having a pattern around the edge of a white plate can be an excellent compromise, giving you the best of both worlds. One exception is with foods from different cultures, where you might use coloured plates to create a feeling of authenticity.

With editorial – where it's customary to give a credit for props – manufacturers, distributors and stores are keen to be featured and are willing to supply products without charge. Experienced stylists will have lots of press officers' contacts, and will easily be able to get the things they need. With advertising, other products are rarely mentioned, so it's necessary to hire them. This is not normally a problem as the budgets tend to be bigger and the cost will have been allowed for. There are plenty of good hire places where you can wander around and find the things you want. Often I'll remember things I've seen before that I know will work and go back and get them.

What can a stylist contribute to a shoot?

Using a stylist means the shot will hang together, that all of the elements will co-ordinate in creating the look and feel required, and present the food at its best. Nothing will jar or distract. For these reasons the result will be a far more polished and professional image. For those same reasons, it's important to have either a good chef or a home economist as well.

What 's the relationship between the stylist, the home economist, the photographer and the art director?

It's important that all these creative people work together as a tight-knit team, and for each to respect the contribution the others are making. What usually happens is that the stylist will start by telling everyone else about the look they have in mind, and through discussion you end up finding a way together.

What skills will a good stylist have?

They will have up-to-date knowledge about food trends: how is it prepared and presented in different kinds of restaurants; what's on the plate or what's served separately; what style of plate, glass and cutlery is in and appropriate for the subject and setting. Also, what kind of things people are eating – what's in and what's out. They will also have a contact book bulging with phone numbers, have lots of creative ideas, and be able to work well as part of a team.

How do you find a good stylist?

The easiest way is to look at magazines that feature food photography. The stylist will usually be credited and editors will normally be willing to provide contact details.

making light work

only by understanding light, measuring it accurately, and using it creatively can you produce food images with impact and style

Whatever the subject, light is the single most important element in any picture – just try taking one without any! And it's the way you use light that generally makes the difference between success and failure. You can have the most attractive or interesting subject in the world, get your exposure and focus perfectly right, but if the lighting's not good you can forget it. Nowhere is that more true than food photography, where subtle use of mirrors and reflectors can make all the difference between also-ran and first-class.

It's astonishing how few photographers pay any real attention to light. Even professionals can be so eager to press the shutter release and get the shot in the bag they don't really think about how to make the light work for them. Getting to know light, and being able to use it creatively, are essential skills for any photographer. One of the best ways of developing and deepening that understanding is to monitor the many moods of daylight. You might find yourself noticing how beautiful the light is on the shady side of a building, or dappled by the foliage of a tree – store that awareness and knowledge away for use when planning a shoot in the future, and recreate aspects of it when shooting raw ingredients or a finished meal. The most astonishing thing about light is its sheer diversity – sometimes harsh, soft; neutral, orange, blue; plentiful, or in short supply.

more doesn't mean better

Taking pictures is easy when there's lots of light. You're completely free to choose whatever combination of shutter speed and aperture you like without having to worry about camera-shake or subject movement – and you can always reduce it with a neutral density filter if there's too much. But don't confuse quantity with quality. Blinding sunshine or light bursting out of a bare studio head may be intense, but it's unlikely that you'd want to take pictures of food and drink in such conditions.

More evocative results are generally achieved when the light is modified in some way – with overall levels often set quite low. With daylight this might be by means of time of day – early morning and late evening being more atmospheric, or by weather conditions, with clouds or even rain or fog producing very different effects. Some of the most dramatic lighting occurs when opposing forces come together – such as a sunbeam in a dark room. In the studio, as well as the number of lights used and their position, it's the accessories you fit which eventually determine the overall quality of the light.

controlling the contrast

For some situations and subjects you will want light that is hard and contrasty, with strong, distinct shadows and crisp, sharp highlights. Outdoors when it's sunny, the shadows are darker and shorter around noon and softer and longer when it's earlier and later in the day. Contrasty lighting can result in strong, vivid images with rich, saturated tones if colour film has been used. However, the long tonal range you get in such conditions can be difficult to capture on film. Care must be taken when doing so that no important detail is lost or that the image doesn't then look either too washed-out or too heavy. If so, some reduction in contrast can often be achieved by using reflectors. This kind of contrasty treatment is not always appropriate; sometimes a more limited tonal range that gives softer results may work better. Where you want to show the maximum amount of detail – often the case with food, but less so with drink – or create a mood of lightness and airiness with the minimum of shadows, the soft lighting of an overcast day or a large softbox is unbeatable.

The degree of contrast also depends upon the direction from which the light is coming. In every picture you are using light to reveal something about the subject – its texture, form, shape, weight, colour or even translucency. Look carefully at what you are going to photograph – its texture, shape and form – and consider what you want to convey about it, then organise the illumination accordingly.

light isn't white

We generally tend to think of light as being neutral or white, but in fact light varies considerably in colour – consider the difference between an orange sunrise and the blue of late twilight. The colour of light is measured in what are known as Kelvins (K), expressed in degrees, and the range of possible light colours is called the Kelvin scale. Standard daylight-balanced film is designed to be used in the sunlight at midday, which typically has a temperature of 5500°K. Electronic flash is the same. However, if you try using daylight film in light of a lower colour temperature you will get a warm, orange colour, while if you use it in light of a higher temperature, you will get a cool, blue tonality. Casts like these are generally regarded as wrong, but if they are used intentionally they can give a shot much more character than the blandness of a clean white light – as if the food were illuminated by late evening sun or actually in a kitchen.

daylight moods

One option for certain kinds of work is to run your studio on daylight, and some professionals do just that – though admittedly only a handful shooting food professionally. But consider the advantages: the light you get is completely natural, unlike flash you can see exactly what you're getting, and it costs nothing to buy and nothing to run. When working outdoors, light can be controlled by means of large white and black boards which can be build around the subject to produce the effect required.

Indoors, you might want to choose a room with north-facing windows. Because no sun ever enters, the light remains constant throughout the day. However it may be a little cool for colour work, giving your shots a bluish cast; if so, simply fit a pale orange colour-correction filter over the lens to warm things up – an 81A or 81B should do fine. Rooms facing other points of the compass will see changes of light colour, intensity and contrast throughout the day. When the sun shines in, you'll get plenty of warm-toned light that will cast distinct shadows. With no sun, light levels will be lower, shadows softer and colour temperature more neutral. The size of the windows in the room also determines how harsh or diffuse the light will be. Having a room with at least one big window, such as a patio door, will make available a soft and even light. The effective size of the window can easily be reduced by means of curtains or by black card for a sharper, more focused light. In the same vein, light from small windows can be softened with net curtains or tracing paper. The ideal room would also feature a skylight, adding a soft downwards light.

With most subjects, but food and drink in particular, you'll need a number of reflectors and mirrors to help you make the most of your daylight studio – allowing you to bounce the light around and fill in shadow areas to contrast.

studio control

Daylight studios are great, but they have obvious disadvantages: you can't use them when it's dark, you can't turn the power up when you need more light, and you don't have anywhere near the same degree of control you get when using studio heads. Being able to place lights exactly where you want them, reduce or increase their output at will, and modify the quality of the illumination according to your needs, means the only limitation is your imagination.

making light work

...continued

Some photographers seem to operate on the basis of 'the more lights the better', using every light at their disposal for every shot. But there's a lot to be said for simplicity, and some of the best food photographs are taken using just one perfectly positioned head. By using different modifying accessories you can alter the quality of its output according to your photographic need. Before going onto more advanced set-ups, it's a good idea to learn to make the most of a single light source – trying it in different positions. If you want to soften the light further, and give the effect of having a second light of lower power, a simple white reflector is all you need.

Having a second head gives you many more options – as well as using it for fill-in you can place it alongside the main light, put it over the top of the subject, on the background, or wherever works well. Having two lights means you can also control the ratio between them, reducing or increasing their relative power to control the contrast in the picture. For many subjects a lighting ratio of 1:4 – i.e. one light having 1/4 of the power of the other – is ideal, but there are no hard-and-fast rules.

In practice, many food and drink photographers will need to have at least three or four heads in their armoury – and unless advanced set-ups are required or enormous fire power, that should be sufficient for most situations. However, it is worth reiterating that it is all too easy to overlight a subject, with unnatural and distracting shadows going in every direction. So before you introduce another light, try asking yourself what exactly it adds to the image? If it adds nothing, don't use it.

which lights when?

The main choice when buying studio heads is tungsten or flash – and there are advantages and disadvantages to both. Tungsten units tend to be cheaper and have the advantage of running continuously, allowing you to see exactly how the light will fall in the finished picture. However, the light has a strong orange content, typically around 3400°K, requiring the use of tungsten film or a blue correction filter for a neutral result. Tungsten lights can also generate enormous heat, making them unsuitable for some food subjects, especially those prone to wilting and melting, such as salads and ice cream. Flash heads are more commonly used because they run at a much cooler temperature, produce a white light balanced to standard film stocks, and have a greater light output. Many studios have both types, and a decision about which to use is based on the requirements of the job in hand.

accessories that assist

Every bit as important as the lights themselves are the accessories you fit on them. Few pictures are taken with just the bare head – unwanted light goes everywhere. To make the light more directional you can fit a dish reflector, which narrows the beam and allows you to restrict it to certain parts of your subject. A more versatile option is provided by barn doors, which have four adjustable black flaps that can be opened out to accurately control the spill of the light. If you want just a narrow beam of light, try fitting a snoot – a conical black accessory which tapers to a concentrated circle.

Other useful accessories include spots and fresnels, which you can use to focus the light, and scrims and diffusers to reduce the harshness. If you want softer illumination, the light from a dish reflector can be bounced off a large white board or – more conveniently, especially for location work – fired into a special umbrella. If that's not soft enough for you, invest in a softbox – a large white accessory that mimics windowlight and is perfect for a wide range of subjects. The bigger the softbox, the more diffuse the light.

measure for measure

Over recent years the accuracy of in-camera meters has advanced enormously. By taking separate readings from several parts of the subject and analysing them against data drawn from hundreds of different photographic situations, they deliver a high percentage of successful pictures. However, the principal problem with any kind of built-in meter remains the fact that it measures the light reflected back from the subject – so no matter how sophisticated it may be, it's prone to problems in tricky lighting situations, such as severe backlighting or strong sidelighting. An additional complication is that integral meters don't know what you're trying to do creatively. So, while you might prefer to give a little more exposure so the shadows have plenty of detail when working with black & white negative film, or you want to reduce exposure by a fraction to boost saturation when shooting colour slides, your camera's meter will come up with a 'correct' reading that tends to produce bland results.

For all these reasons, any self-respecting professional photographer or serious amateur will invest in a separate lightmeter, which will give them full control over the exposure process – and 100 per cent accuracy. Hand-held meters provide you with the opportunity to do something your integral meter never could – take an incident reading of the light falling onto the subject. With a white invercone dome fitted over the sensor, all the light illuminating the scene is integrated, avoiding any difficulties caused by bright or dark areas in the picture. When using filters, you can either take the reading first and then adjust the exposure by the filter factor – if you know it, or you can hold the filter over the sensor when making a measurement. Those seeking unparalleled control over exposure should consider buying a spot meter, which allows you to take a reading from just one per cent of the picture area. Most have a viewfinder you look through when measuring exposure. At the centre is a small circle, which indicates the area from which the reading is made.

Many of the more expensive hand-held meters, both incident and spot, have a facility for measuring electronic flash as well. For those who don't feel the need for an ambient meter, separate flash-only meters are available. The benefit of having a meter that can measure flash is obvious. In the studio it allows you to make changes to the position and power of lights and then quickly check the exposure required. And when using a portable electronic gun you can use it to calculate the amount of flash required to give a balanced fill-in effect. Incident flash meters are used in exactly the same way as when taking an ambient reading. The meter is placed in front of the subject, facing the camera, and the flash fired. This can usually be done from the meter itself, by connecting it to the sync cable and then pressing a button.

Another useful feature that's widely available allows you to compare flash and ambient readings – perfect if you're balancing flash with ambient light or want to mix it with tungsten. Some of the more advanced flash meters can also total multiple flashes – ideal if you need to fire a head several times to get a small aperture for maximum depth-of-field, such as when you want the food and the background both in focus.

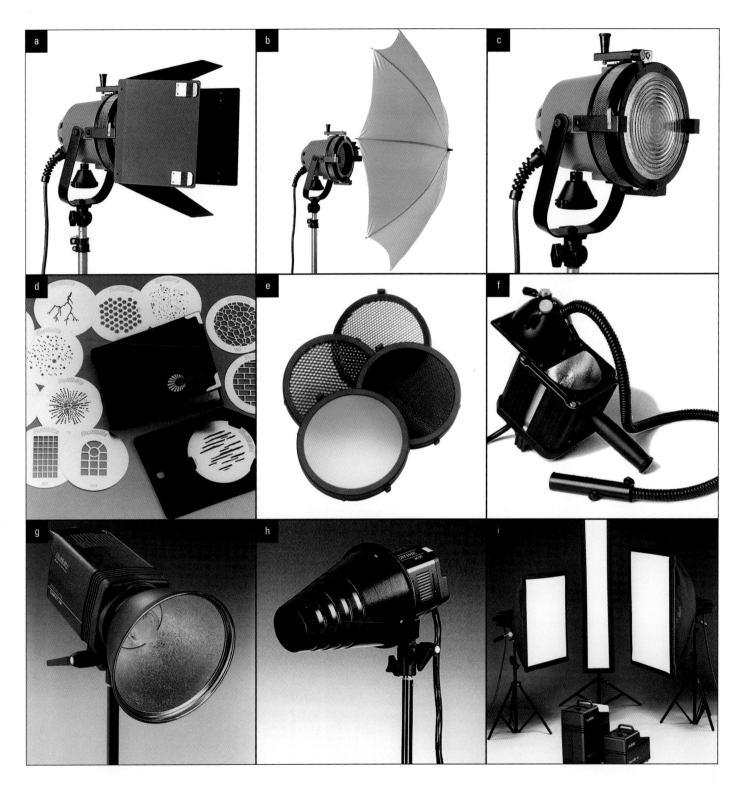

glossary of lighting terms

Acetate
Clear plastic-like sheet often colour-tinted and fitted over lights for a colour cast

Ambient light
Naturally occurring light

Available light
See Ambient light

Back-projection
System in which a transparency is projected onto a translucent screen to create a backdrop

Barn doors (a)
Set of four flaps that fit over the front of a light and can be adjusted to control the spill of the light

Boom
Long arm fitted with a counterweight which allows heads to be positioned above the subject

Brolly (b)
See Umbrella

CC filters
Colour correction filters, used for correcting any imbalance between films and light sources

Continuous lighting
Sources that are always on, in contrast to flash, which only fires briefly

Cross-processing
The use of unconventional processing techniques, such as developing colour film using black & white chemistry

Diffuser
Any kind of accessory which softens the output from a light

Effects light
Light used to illuminate a particular part of the subject

Fill light
Light or reflector designed to reduce shadows

Fish fryer
Extremely large softbox

Flash head
Studio lighting unit which emits a brief and powerful burst of daylight-balanced light

Flag
Sheet of black card used to prevent light falling on parts of the scene or entering the lens and causing flare

Fluorescent light
Continuous light source which often produces a green cast with daylight-balanced film – though neutral tubes are also available

Fresnel (c)
Lens fitted to the front of tungsten lighting units which allows them to be focused

Giraffe
Alternative name for a boom

Gobo (d)
Sheet of metal or card with areas cut out, designed to cast shadows when fitted over a light

HMI
Continuous light source running cooler than tungsten but balanced to daylight and suitable for use with digital cameras

Honeycomb (e)
Grid that fits over a lighting head producing illumination that is harsher and more directional

Incident reading
Exposure reading of the light falling onto the subject

Joule
Measure of the output of flash units, equivalent to one watt-second

Kelvin
Scale used for measuring the colour of light. Daylight and electronic flash is balanced to 5500°K

glossary of lighting terms

...continued

Key light
The main light source

Kill spill
Large flat board designed to prevent light spillage

Lightbrush (f)
Sophisticated flash lighting unit fitted with a fibre-optic tube that allows the photographer to paint with light

Light tent
Special lighting set-up designed to avoid reflections on shiny subjects

Mirror
Cheap but invaluable accessory that allows light to be reflected accurately to create specific highlights

Mixed lighting
Combination of different coloured light sources, such as flash, tungsten or fluorescent

Modelling light
Tungsten lamp on a flash head which gives an indication of where the illumination will fall

Monobloc
Self-contained flash head that plugs directly into the mains (unlike flash units, which run from a power pack)

Multiple flash
Firing a flash head several times to give the amount of light required

Perspex
Acrylic sheeting used to soften light and as a background

Ratio
Difference in the amount of light produced by different sources in a set-up

Reflector
1) Metal shade around a light source to control and direct it (g)
2) White or silvered surface used to bounce light around

Ringflash
Circular flash tube which fits around the lens and produces a characteristic shadowless lighting

Scrim
Any kind of material placed in front of a light to reduce its intensity

Slave
Light-sensitive cell which synchronises the firing of two or more flash units

Snoot (h)
Black cone which tapers to concentrate the light into a circular beam

Softbox (i)
Popular lighting accessory producing extremely soft light. Various sizes and shapes are available – the larger they are, the more diffuse the light

Spill
Light not falling on the subject

Spot
A directional light source

Spot meter
Meter capable of reading from a small area of the subject – typically one to three degrees

Stand
Support for lighting equipment (and also cameras)

Swimming pool
Large softbox giving extremely soft lighting (see also Fish fryer)

Trace
See Scrim

Tungsten
Continuous light source

Umbrella (b)
Inexpensive, versatile and portable lighting accessory. Available in white (soft), silver (harsher light), gold (for warming) and blue (for tungsten sources). The larger the umbrella, the softer the light

practicalities

How to gain the most from this book

The best tools are those which can be used in many different ways, which is why we've designed this book to be as versatile as possible. Thanks to its modular format, you can interact with it in whichever way suits your needs at any particular time. Most of the material is organised into self-contained double-page spreads based around one or more images – though there are also some four page features that look at the work of a particular photographer in more depth. In each case there are at least two diagrams which show the lighting used – based on information supplied by the photographer. Copy the arrangement if you want to produce a shot that's similar. Naturally the diagrams should only be taken as a guide, as it is impossible to accurately represent the enormous variety of heads, dishes, softboxes, reflectors and so on that are available, while using an accessible range of diagrams, nor is it possible to fully indicate lighting ratios and other such specifics. The scale, too, has sometimes had to be expanded or compressed to fit within the space available. In practice, however, differences in equipment, and sometimes scale, should be small, and will anyhow allow you to add your own personal stamp to the arrangement you're seeking to replicate. In addition you'll find technical details about the use of camera, film, exposure, lens etc. along with any useful hints and tips.

icon key

- ⊛ Photographer
- ⊘ Client
- ◑ Possible uses
- ⊛ Camera
- ◐ Lens
- ▣ Film
- ◷ Exposure
- ◔ Type of light

understanding the lighting diagrams

three-dimensional diagrams

large-format camera

medium-format camera

35mm camera

standard head

standard head with barn doors

spot

spot with honeycomb

spot with snoot

softbox

diffuser

strip light

reflector

backdrop

trace (shown transparent)

plan view diagrams

large-format camera

medium-format camera

35mm camera

standard head

standard head with barn doors

spot

spot with honeycomb

spot with snoot

softbox

diffuser

strip light

reflector

backdrop

trace

21

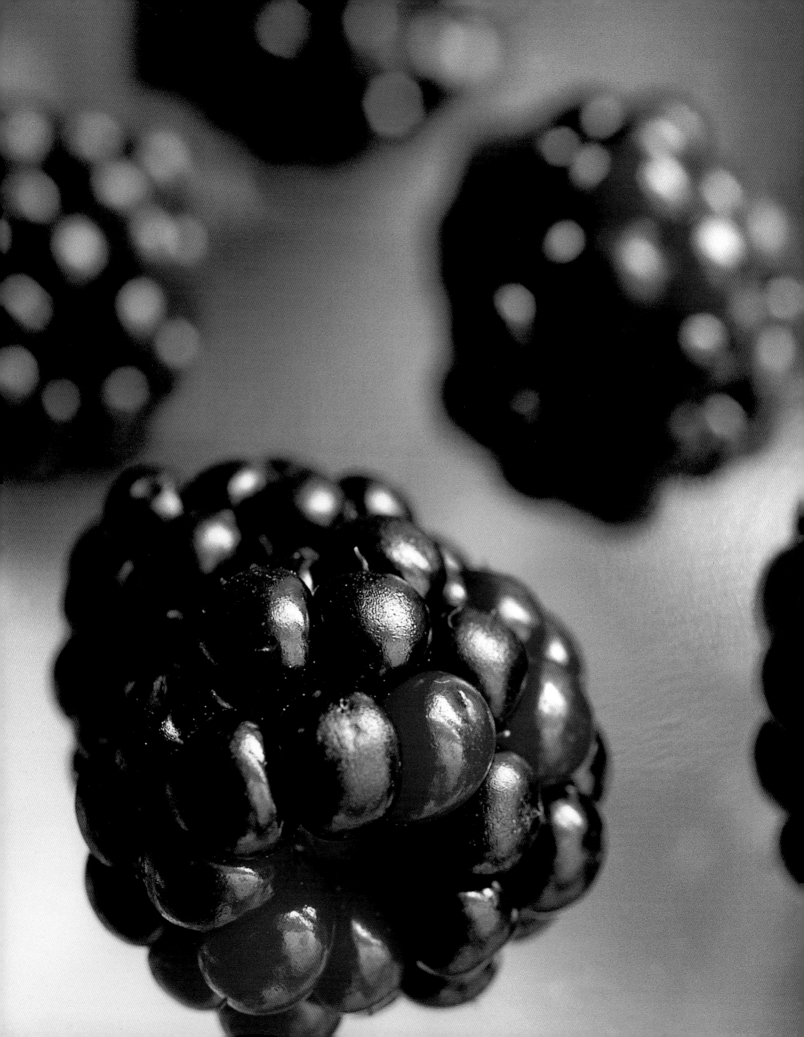

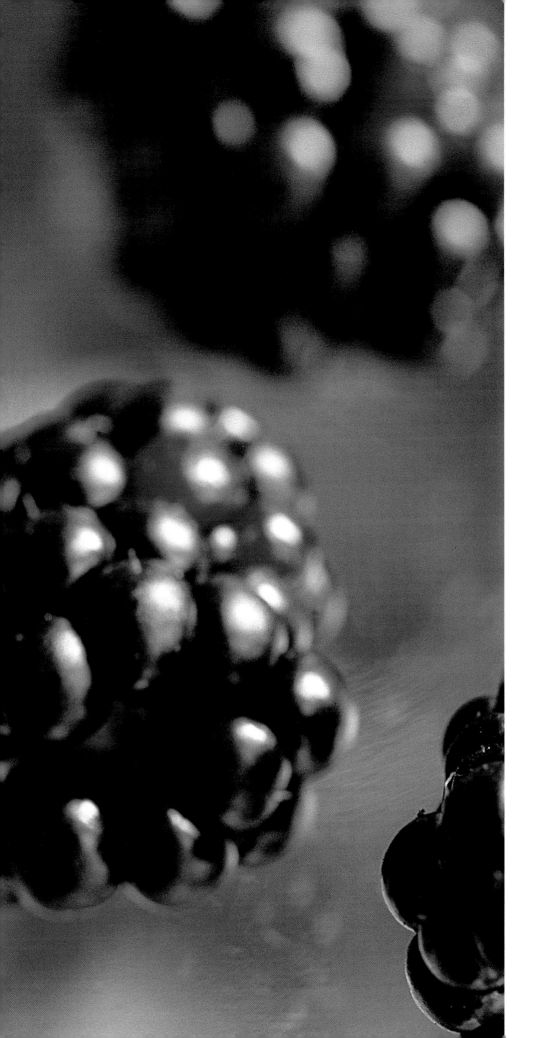

daylight / ambient

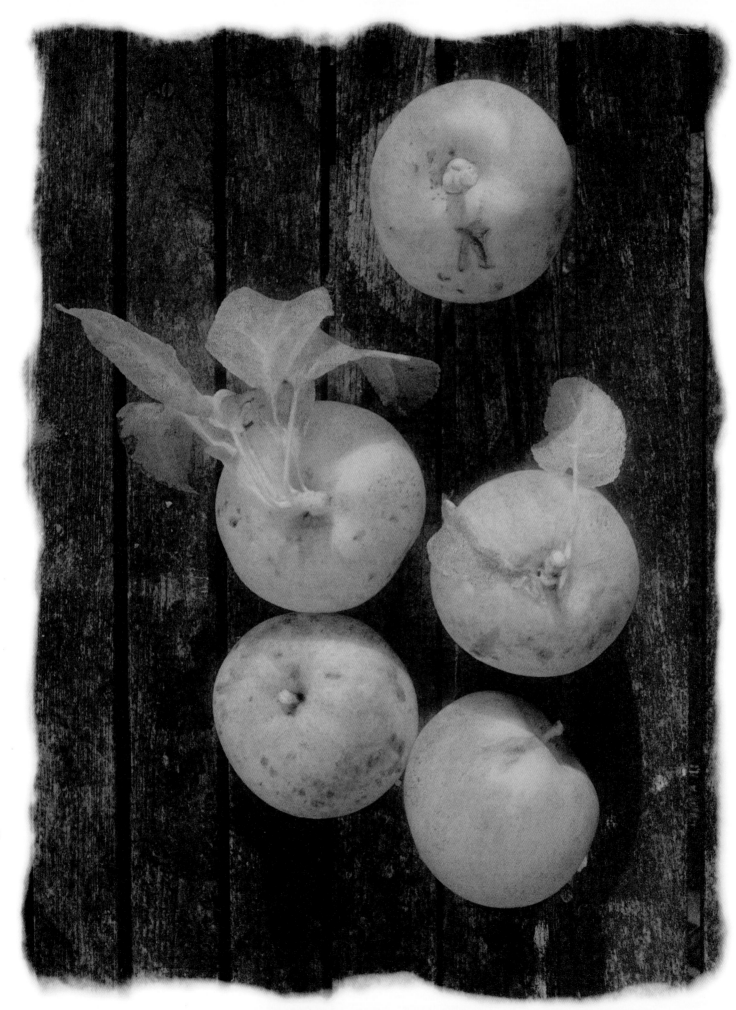

This photograph was taken directly under the tree on which the apples had grown. Kathleen Harcom just selected a handful, laid them out on an old garden table, and shot from directly overhead. The branches above cut out most of the toplight, resulting in a slightly contrasty sidelight which revealed the texture of the fruit.

To produce an atmospheric and artistic image, Harcom used black & white infrared film, sepia-toning the print she made on canvas paper and then hand-colouring parts of the image using Marshall's Oils – paints specially formulated for hand-colouring black & white prints.

(人) Kathleen Harcom
(⊘) Personal project
(◈) Portfolio
(▣) 35mm
(◉) 50mm macro
(▶) Kodak High Speed Infrared
(⊙) f/16 at 1/125sec
(⊙) Dappled daylight

mono infrared film

Black & white infrared film is a great choice where a more creative and moody treatment is required. As well as featuring a visible grain structure, it also produces a reversed tonality if you use a red filter over the camera. Warm colours, such as red, orange and yellow, come out much lighter than usual, while cool colours, such as blue, are much darker. Strong sources of infrared – such as foliage in particular – usually appear luminescent.

plan view

apples

Shooting under a tree kills any light from above and results in texture-revealing sidelight.

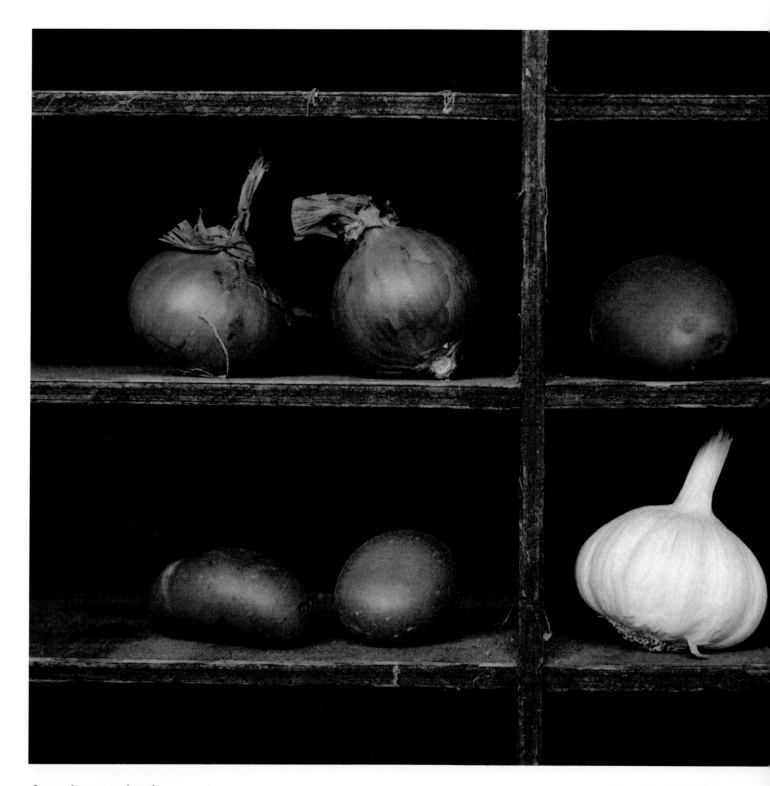

food on shelves

Nothing beats windowlight when soft lighting is required.

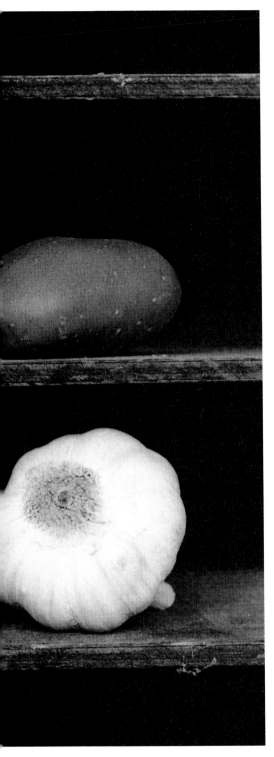

It would be hard to mimic the diffuse lighting used for this wonderful study in form and texture – you would need a softbox measuring 2 x 1m, the size of the window used.

The potatoes, shallots and garlic are all arranged on the shelves of an old toolbox turned on its side and resting on the table. The camera is placed square to the subject, and the window is behind photographer Kathleen Harcom. Because she wanted as soft a light as possible, she took the pictures in the middle of the morning, when the sun was covered with cloud, and used net curtains to diffuse the light further. The original black & white image (see inset) was printed on art paper, sepia-toned, and then hand-coloured.

Kathleen Harcom
Personal project
Exhibition
6 x 4.5cm
75mm
Agfa APX-25
f/16 at 1/8sec
Daylight

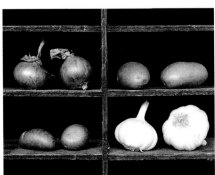

While the black & white treatment has undoubtedly been successful here, in fact it's not widely used in food and drink photography – and then most often for raw ingredients rather than finished dishes. The reason is almost certainly that in this context, colour is more important than shape and tone in bringing the subject to life.

plan view

If you ever wanted proof of how perfect daylight can be when it comes to pictures of food, then this has to be it. The bright colours and the intricate detail of the mushroom are revealed by the softness of the illumination. It was taken in the course of shooting a feature about mushroom-picking, in the open air on a winter's day.

'It was a very simple picture to take,' says Jean Cazals. 'The chef was holding the mushroom in his hand and I used a 35mm camera to photograph it. The dark brown coat he was wearing provided the ideal background to make the hand and mushroom stand out.'

- Jean Cazals
- Good Housekeeping magazine, UK
- Editorial
- 35mm
- 100mm macro
- Kodak Ektachrome E100S
- f/2.8 at 1/250sec
- Daylight

plan view

mushroom in hand

28

Where detail and clarity are required, nothing beats daylight outdoors.

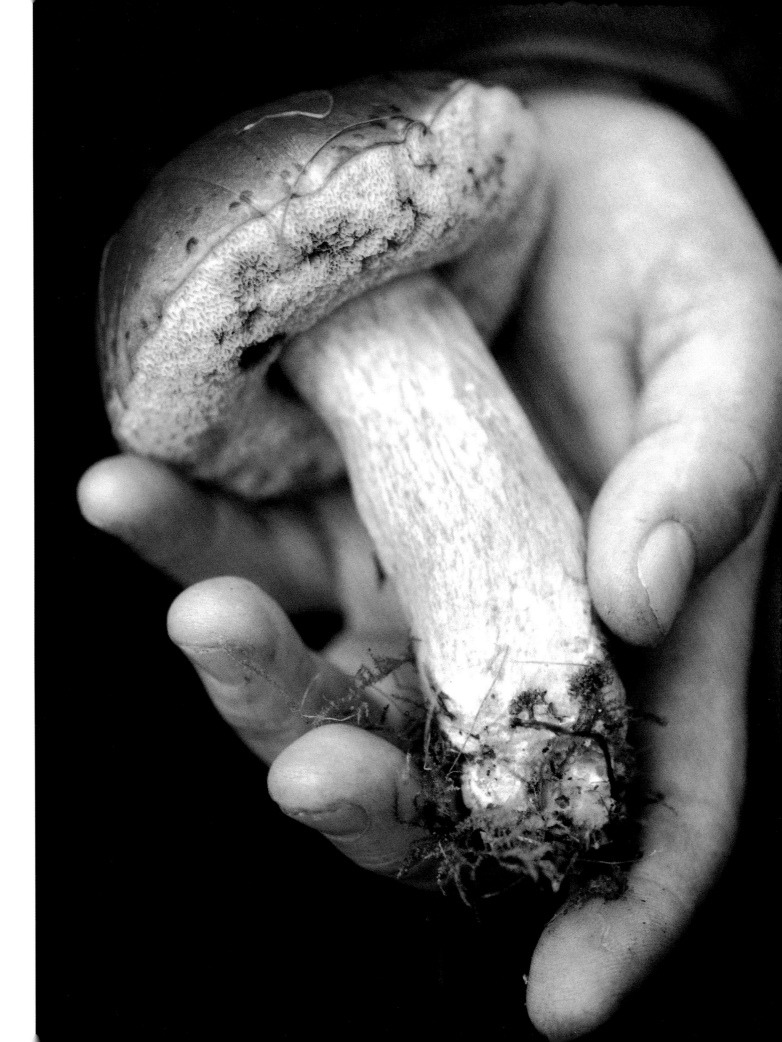

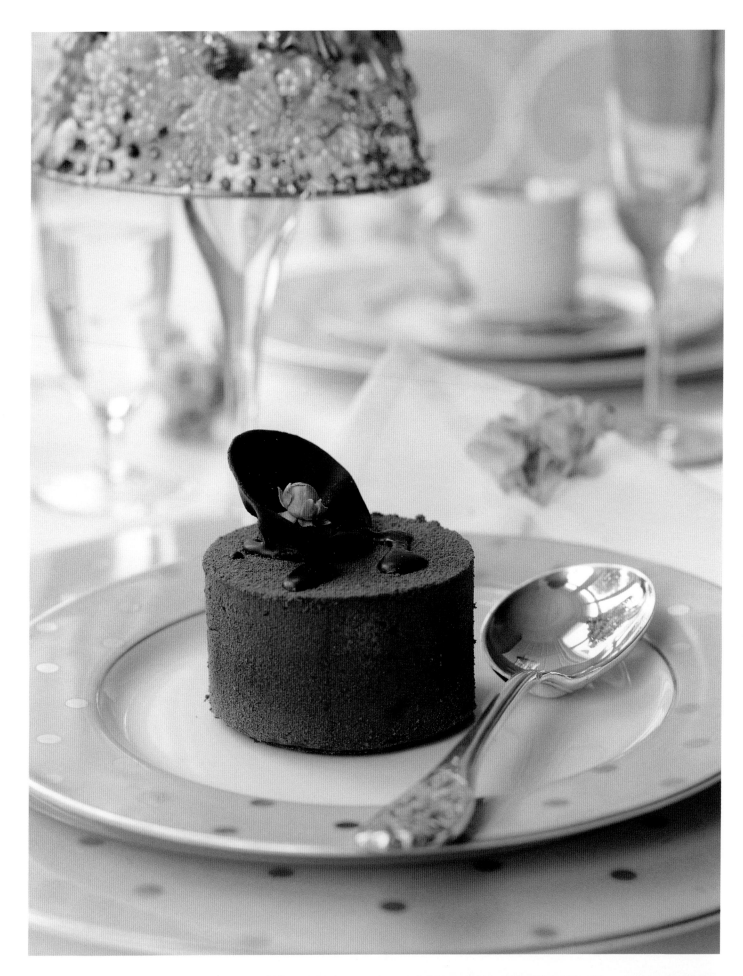

'Daylight is a very simple thing, and can be perfect for food photography,' says Cazals, 'but the important thing is to control it. You need to be able to use reflectors and scrims to produce the effect you want – minimising dark shadows and modifying the highlights. What I do is to add and subtract them, move them around, until I am happy with the result.'

The light for this beautifully lit and wonderfully composed picture is coming from the left – a window that's 3m long and 2.2m high. The bigger the light source the softer the light, and here the illumination is extremely diffuse. A 30 x 15cm white reflector was placed on the right-hand side of the spoon, to fill in the darkness on the shadow side of the chocolate. On the left-hand side, held in the air with a clamp, a black strip around 30 x 7.5cm was used to kill the highlight on the top left-hand side of the cake.

ⓧ Jean Cazals
⊙ Harpers & Queen magazine, UK
◉ Editorial
⊛ 6 x 7cm
◉ 80mm macro
▶ Kodak Ektachrome E100S
⊘ f/5.6 at 1/4sec
◔ Daylight

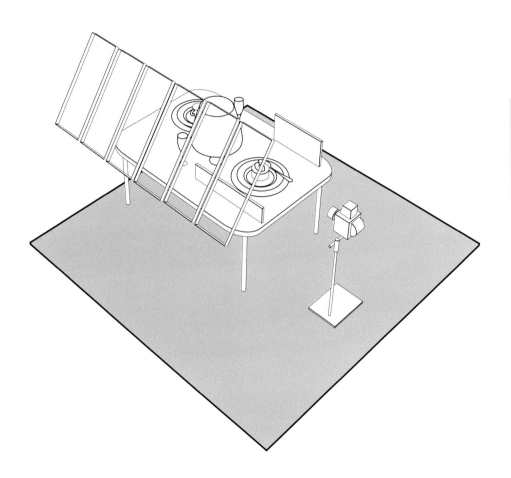

plan view

on daylight

'I use daylight for 90 per cent of my shots,' says Cazals, 'and when I don't use it I try to recreate it using flash.'

chocolate torte

Positive and subtractive reflectors make it possible to fine-tune daylight.

reportage-style food photography

Photographing food as it's being prepared results in fresh, spontaneous images

For many of its practitioners, food photography is a branch of still-life photography, and their approach is typical of the genre – painstaking arrangement of the elements, a large-format camera for maximum quality, precise lighting control, and a succession of Polaroids to make sure absolutely everything is perfect.

This is not how Francesca Yorke usually works. Her preferred style is photojournalistic and, more like news reportage photography, capturing things as they happen using daylight and a 35mm camera rather than spending several hours contriving set-ups.

Yorke's pictures are often taken in working restaurants, or as chefs are preparing food, and so it's the only practicable approach. Setting up lights and using a studio camera just isn't an option. You have to be discreet. 'Sometimes I'll be lurking in the kitchen, photographing dishes as they're got ready, and I may have just seconds before they're whisked away to a customer. It's a rapidly changing situation, so you have to be hyper-alert and stay focused all the time. It's also very exhausting, by the end of the day I'm often utterly shattered.'

'The way I shoot is really straightforward and simple. Whenever possible I work with available light. If I can't shoot hand-held I use a tripod, and if that's not convenient, or the light's not good enough, then I use extra lighting – generally a small tungsten light fitted with blue gels that I clamp to the table. Most of my pictures are taken on a 60mm lens, or, when I need a wider perspective, a 24mm lens.'

'I like to work fast, trying to catch the moment. I work instinctively. I don't really analyse what I do. Most of the time I only shoot three frames of each shot. If the dish or set-up is laboured over, and people are moving things around and discussing it, that tends to take all the life out of it for me. I don't like to fiddle with food very much. I try to keep it as natural as possible. I don't use Polaroids – ever. Clients tend to be a little bit nervous the first time. But they've never been disappointed and they know they can trust me.'

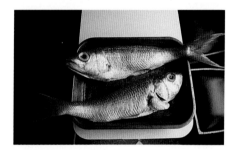

fish on tray

It's the sense of reality you get from this shot that makes it so powerful. It is completely without artifice. Nothing has been done to make the fish look more appealing. The use of a 24mm wide-angle lens even includes the surrounding area, which would normally have been cropped out. 'The chef came out with the fish on the baking tray, put it on the table, and I stood on a chair and took the picture,' says Yorke. 'The light was coming in through a window on the right-hand side; the contrast it produced was perfect for revealing the texture of the fish.'

beetroot and cream

It's the rich, vibrant colours of this shot that make it seem to leap off the page. Adding the white of the cream to the primary colours of red and blue produces a powerful and contrasty combination. The effect is enhanced by using Fujichrome Velvia, one of the best transparency films around.

The shot was taken on location on the border between France and Switzerland. It was a bright day, and the light was streaming in through a small window to the left. Nothing was set up.

ready for serving

While this shot looks as if it could easily have been styled and arranged carefully, in fact it was caught on the spur of the moment using a reportage-style approach. The pan had just been removed from the oven, and Yorke literally photographed it as it was being set down briefly on the worktop. Happily the tungsten light above illuminated it beautifully, making the watercress and melting butter glisten appealingly.

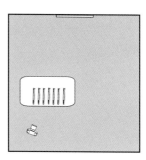

fresh fish

'I like food to look fresh, real and not too pretty,' says Yorke, 'and my clients like that too. In the eighties everything was so controlled, but it's wonderful to be more spontaneous in your approach.' Here the fish were just waiting to be prepared on a reflective stainless-steel surface, and Yorke saw the potential for the shot. By taking a low viewpoint, she was able to bring an unexpected and dramatic perspective to the subject. Using a large aperture limits the depth-of-field so that the potentially distracting background, including the sink on the left, are all thrown out of focus – as indeed are most of the other fish heads.

Francesca Yorke
Recipe book
Editorial
35mm
24mm
Fujichrome Velvia
Not known
Daylight

33

Taking a few items of food and improvising an interesting picture couldn't be easier – as photographer Francesca Yorke demonstrates here. 'This was taken in my own kitchen,' she says. 'The blackberries are on an ordinary sheet of glass that's resting on four cans of baked beans – one at each corner – lifting them around 75 cm off the worktop.'

'I was right by the window, which is only 1m high and quite narrow – so the light was fairly contrasty. I got in close with a macro lens on my hand-held camera to fill the frame, and set a large aperture so only the blackberry in the foreground is sharp.'

plan view

floating blackberries

Raising food up on glass makes it look as if it is floating.

- Francesca Yorke
- Personal project
- Portfolio
- 35mm
- 60mm macro
- Fujichrome Velvia
- Not known
- Daylight

macro lenses

With subjects that are particularly small, a special
macro lens may be required to be able to produce
a frame-filling composition. Generally these optics
give you a 1:1 reproduction ratio – that is, the
subject will be the same size on film as it is in real
life. Using them is essentially the same as with
conventional lenses, although because the front
of the subject may be much closer than normal,
you have to make sure when lighting that the lens
doesn't throw a shadow onto it.

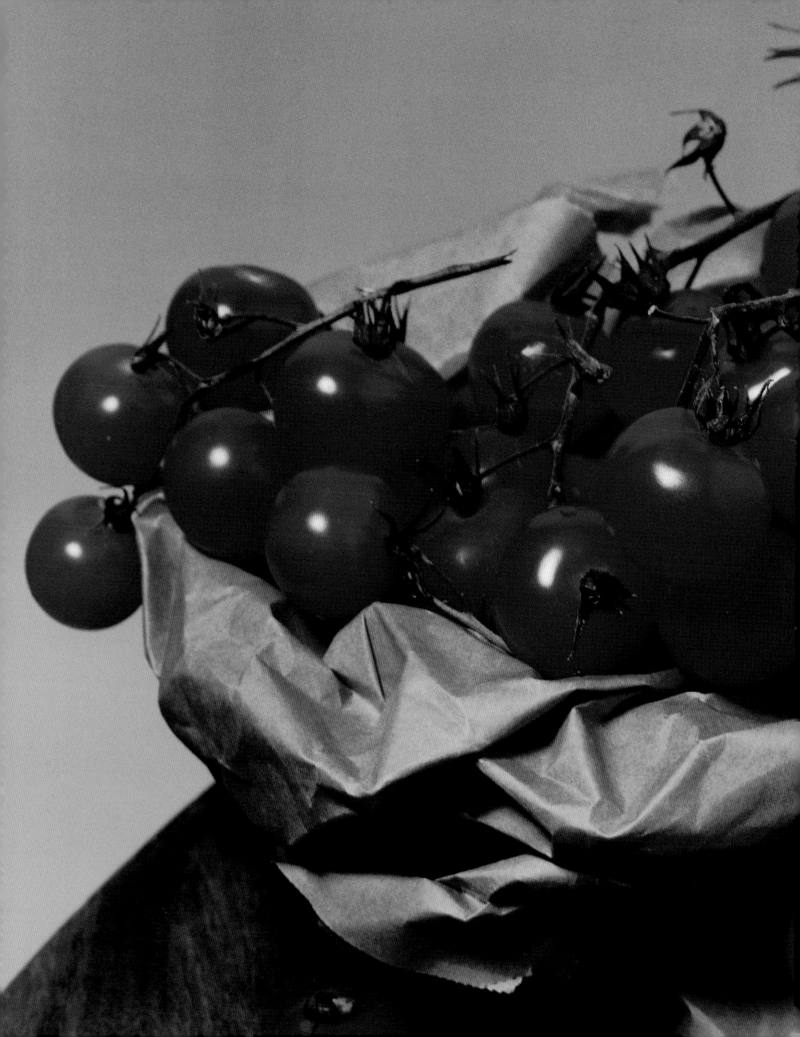

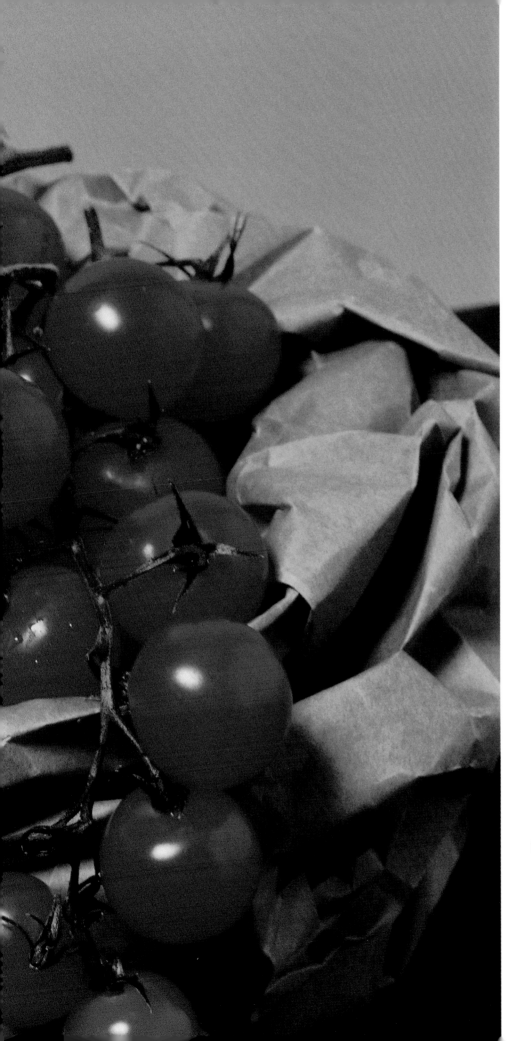

a single source

backlit pasta

An ordinary lightbox provides an ideal means of backlighting pasta.

With food that's thin or transparent, one simple way of revealing its shape and texture is to light it from behind. The conventional approach is to use a softbox, perhaps with a sheet of Perspex over the top for extra diffusion. However, with smaller subjects there's an easier way – using a daylight-balanced lightbox that you may already have in the studio for viewing transparencies and negatives.

Here, the pasta was simply laid on the surface of the lightbox and the camera anchored to a tripod directly above. Exposure was set so the background reproduced as pure white, whilst the overlapping of the strands create the different tonalities within the pasta.

Ⓐ Lee Frost
Ⓢ Personal project
Ⓢ Stock image
Ⓜ 35mm
Ⓛ 105mm macro
Ⓕ Fujichrome Sensia 100
Ⓒ f/8 at 1 second
Ⓛ Daylight-balanced lightbox

plan view

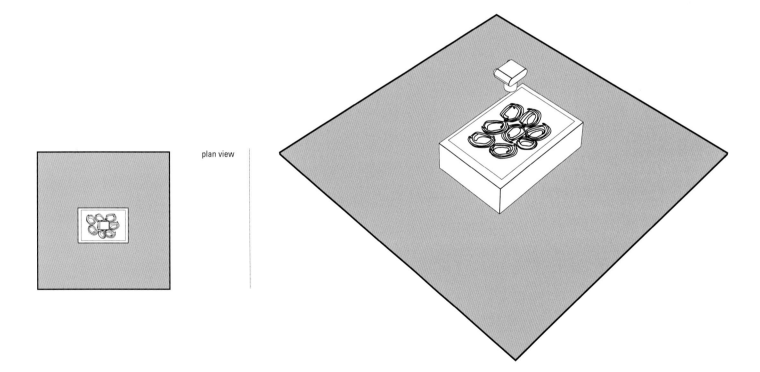

If you want to simply show the shape of a bottle or glass that's filled with a dark liquid, such as red wine, you need to light it in such a way that the edge of the container is illuminated while the centre remains dark.

There are a number of complex techniques for achieving this – for example using strip lights either side and building a frame around the subject to avoid any potential flare – but a more straightforward approach is to modify a softbox with a large sheet of black card. Tape the card over the central vertical section, so there's a strip of light down either side. Position the subject in front of the light so the black card provides the background within the frame. All that remains is to determine the exposure – by Polaroid if you have that option, or by shooting a roll of test film at different apertures.

ⓧ Lee Frost
⊖ Personal project
◉ Stock image
⊞ 35mm
◉ 105mm macro
▣ Fujichrome Sensia
◷ f/11–16 at 1/60sec
◉ Electronic flash

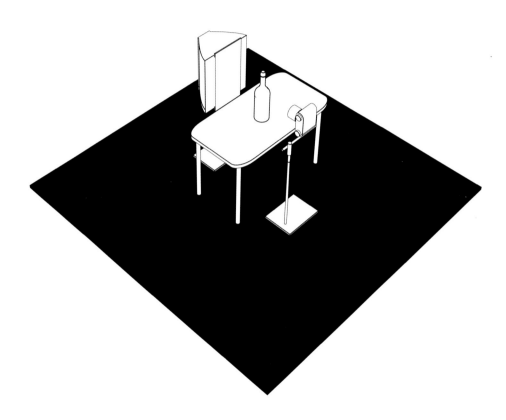

plan view

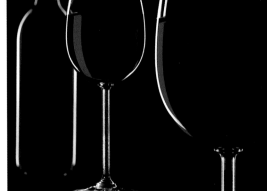

wine glasses

An easy-to-use way of producing rim-lighting for glasses and bottles is to modify a softbox with black card.

avoiding flare

41

It's important when shooting towards a light source to flag it off carefully, so as to avoid flare. Balance the exposure accurately to avoid the backlight burning out and creating a sense of softness.

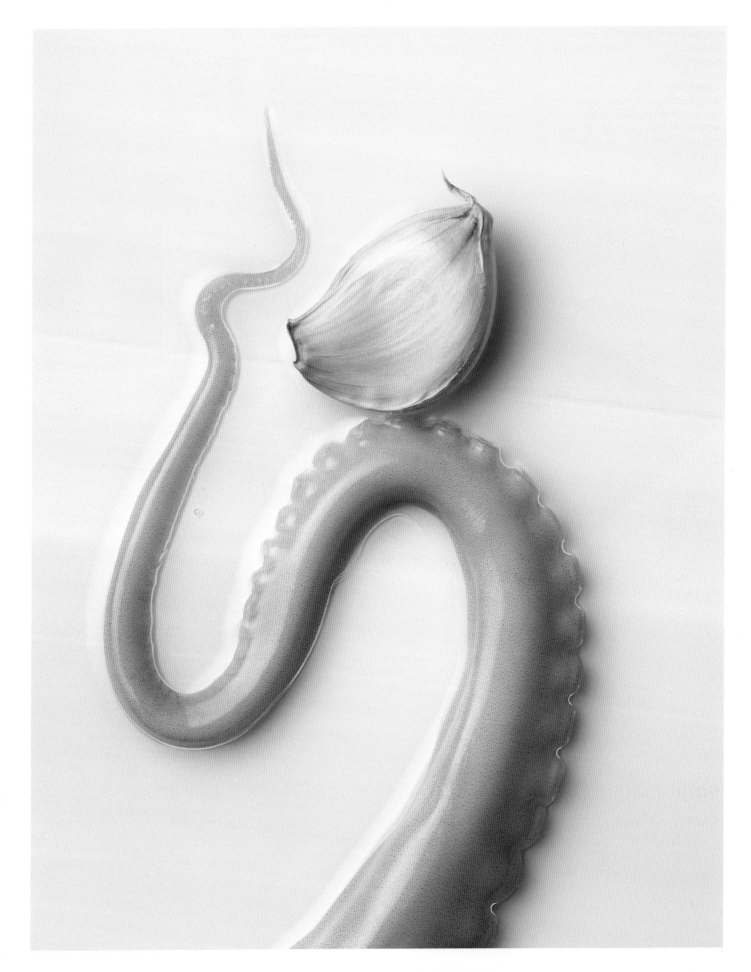

First-class food photography is often about bringing together contrasting elements in an original and eye-catching way. Here, the juxtaposition of the slimy, wriggly squid tentacle and the smooth, dry garlic is truly inspired. Using compatible ingredients of a similar hue refines the effect.

'My philosophy is that it's easy to do a pretty picture of most objects,' says Patrice de Villiers, 'but to create a photograph of lasting and dynamic beauty you need to look at the subject in a different and extraordinary way. The difficult task is to find a way of shooting the elements together which simultaneously makes some sort of sense and creates an interesting and beautiful picture. Lighting is an essential part of that: here I used a fish fryer angled down from the top left-hand side, with white card angled up on the bottom right to create fill in order to reduce contrast.'

'I used a thin layer of olive oil on the background to provide the slight yellow tone. The highlight which runs down the side of the tentacle also emphasises its oily nature.'

Patrice de Villiers
Independent on Sunday magazine, UK
Editorial
5 x 4 inch
210mm
Fujichrome Velvia
f/32 at 1/125sec
Electronic flash

plan view

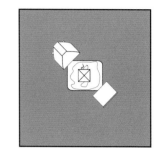

a clear understanding

'I tend to shoot quite basically from a lighting point of view. Usually there is one main light source, and the quality of that lighting is dictated by a number of factors: how high or low; how far away from the subject; whether it's diffused by using a trace screen or used as a harder light on its own; the amount of light taken away from the subject and the shadows one keeps or adds by use of flags; and/or the amount of fill put into the shadows to control the contrast ratio.'

squid and garlic

Bringing together contrasting elements helps to create memorable images.

Simple props can make an enormous difference when it comes to producing food and drink shots that look authentic. In French markets you often see vegetables wrapped up in an old newspaper, and Frost was seeking to recreate that effect here. Having obtained a copy of the French newspaper Le Monde, he crumpled it up and arranged it beneath the string of garlic bulbs, so that the masthead was visible.

A daylight feel was produced by placing a single softbox low and to the far side of the set-up. The overall softness of the image was further enhanced by using a fast film pushed two stops, to produce a grainy appearance, and a soft-focus filter.

ⓧ Lee Frost
☉ Personal project
◉ Stock image
⬤ 6 x 7cm
◉ 105mm macro
▣ Fujichrome RHP400 (pushed two stops)
◴ 1/15sec at f/11
◉ Electronic flash

plan view

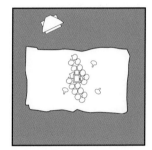

44 garlic on paper

It's surprisingly easy to put together convincing table-top set-ups with just a few props and a single light.

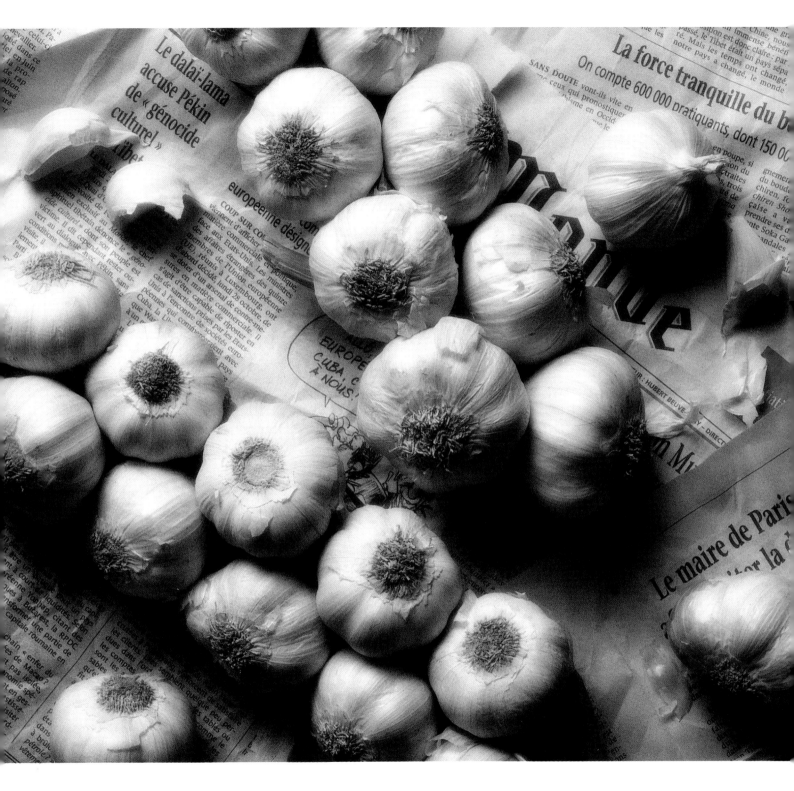

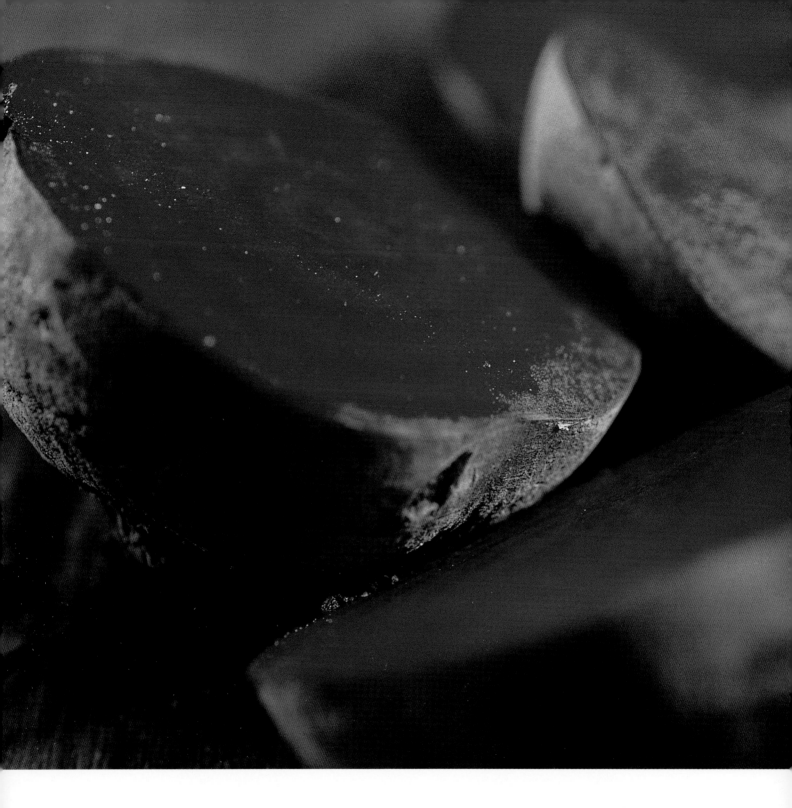

'sensual' lighting for food

Soft lighting from indoor windowlight produces harmonious compositions

People often describe Francesca Yorke's food images as 'sensual'. In saying that they almost certainly mean that it stimulates all of the senses – and this is achieved by the intimate way in which she captures the texture and form of the things she photographs. 'I don't really think of it as food,' she explains. 'I just look at it objectively, concentrating on the shape and capturing that on film in a tactile as well as a visual way.'

The resulting images, tightly cropped and with the attention fully on the subject, display a wonderful sense of harmony and composition. Part of this

 Francesca Yorke
Recipe book
Editorial
35mm
60mm macro
Fujichrome Velvia
Not known
Tungsten and daylight

plan view

derives from Yorke's skilled use of the soft illumination achieved with windowlight indoors. She also prefers it when the art direction is left entirely up to her – as was the case when shooting the images on this page for a recipe book. 'Sometimes they would give me a recipe and allow me to choose any of the ingredients to photograph – and arrange them how I wanted. I might shoot them whole, peel it or cut it into pieces, according to how I felt about them. Not having to show the finished dish or some "step-by-step" sequence was extremely liberating.'

cut beetroot

Simply cutting a beetroot into slices reveals the luscious richness of its flesh – and going in close with a macro lens fills the frame with vibrant colour. The main source of illumination is the daylight that's coming in from a small window at the back right. This is balanced with illumination from a small tungsten light fitted with gels clamped to the table on the left.

47

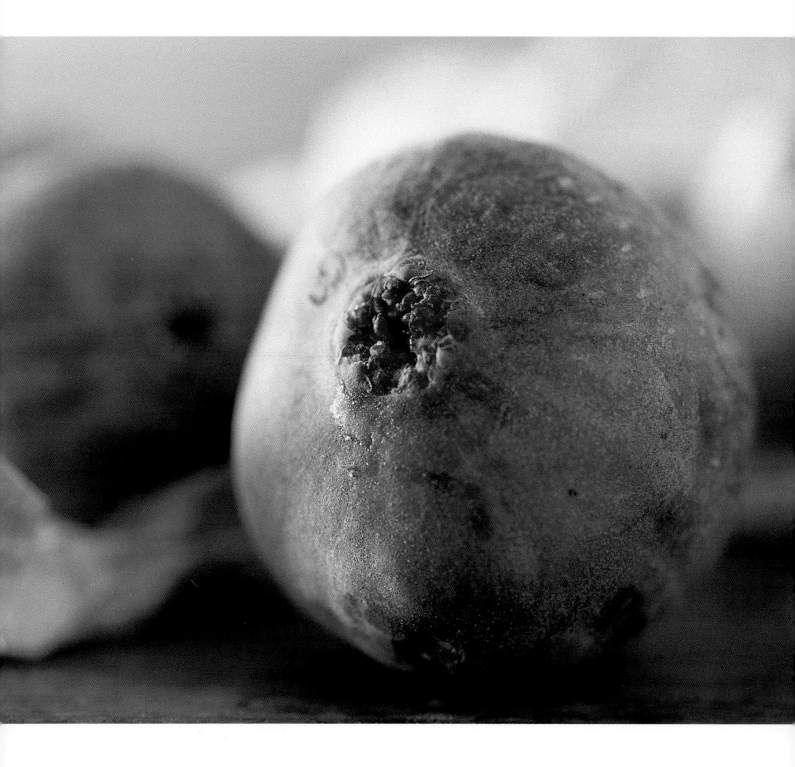

figs

Placing the light behind the subject, in this case a large window at the back and left, and then exposing for the shadow side makes the background 'blow out' – creating burnt-out highlights, and a soft, harmonious composition.

- Francesca Yorke
- Recipe book
- Editorial
- 35mm
- 60mm macro
- Fujichrome Velvia
- Not known
- Daylight

fujichrome velvia

Launched in 1990, Fujichrome Velvia set a new standard in transparency film quality – a standard so high that even now no other film comes close to matching its performance. No wonder, then, that it's the first choice for many discerning professionals, including food photographers. Some leading photo libraries even insist that all contributors use Velvia and nothing else – simply because the images seem to leap off the lightbox and as a result sell more easily. The name 'Velvia' is a combination of the worlds 'velvet' and 'media' – an apt description of the incredible depth of colour and delicate texture possible with this versatile film. Colours are rich and vivid, but with subtle differentiation of tones, and with its ultra-fine grain and incredible sharpness, Velvia captures intricate detail perfectly. The result is a punchy transparency with a three-dimensional quality that makes the image seem almost real. The claimed ISO 50 sensitivity, though, is a little optimistic, and most food and other professionals rate it at ISO 40.

plan view

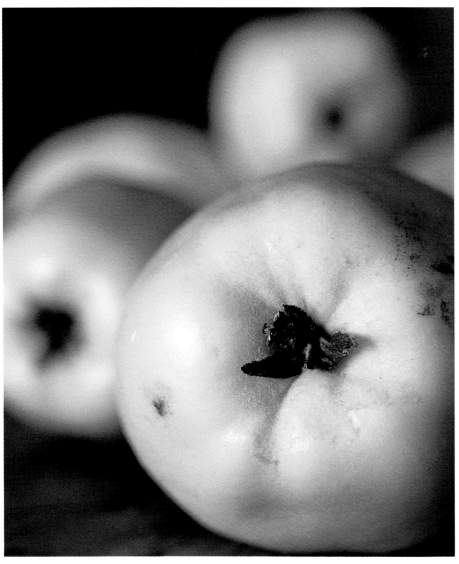

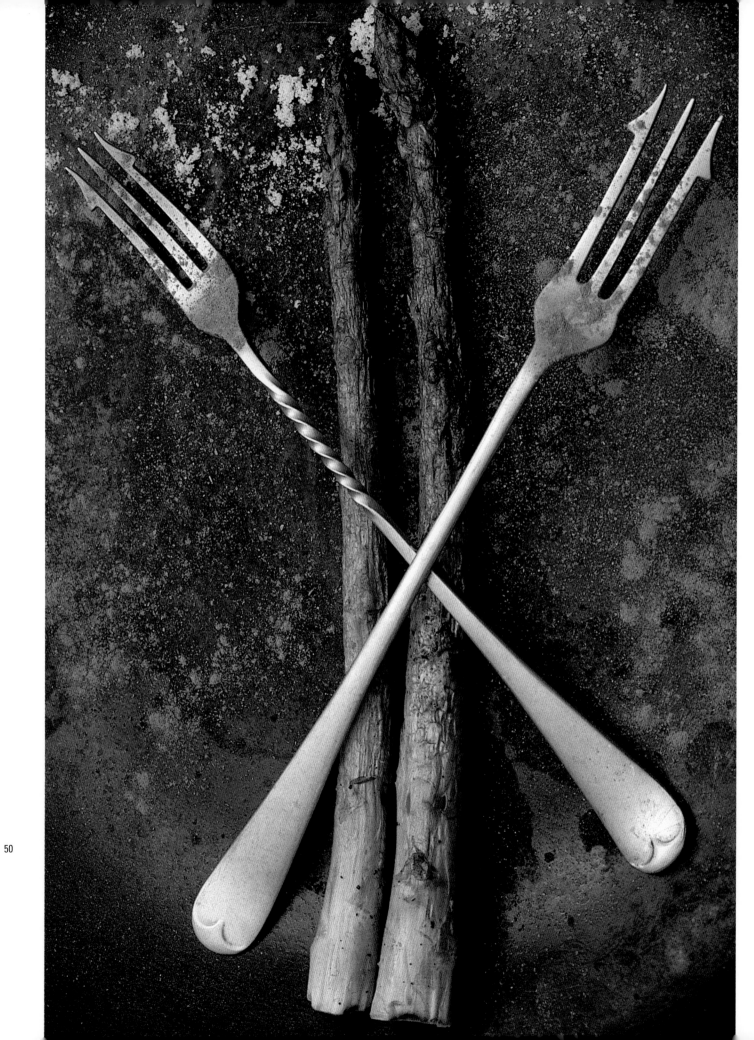

Looking to produce 'something very stylised but very simple', photographer Karen Parker assembled the attractive pickle forks and cooked asparagus on an old iron plate and then sprinkled the set with salt and mixed spices.

In order to bring out the texture of the vegetables, while at the same time avoiding any hot spots on the cutlery, Parker used just one light. This was a softbox 61cm to the left of the camera, angled down at 45 degrees and supplemented by a large, circular cake board pointing down at the same angle on the right-hand side.

Karen Parker
Personal project
Stock image
35mm
105mm macro
Agfachrome RS 50
f/11 at 1/60sec
Electronic flash

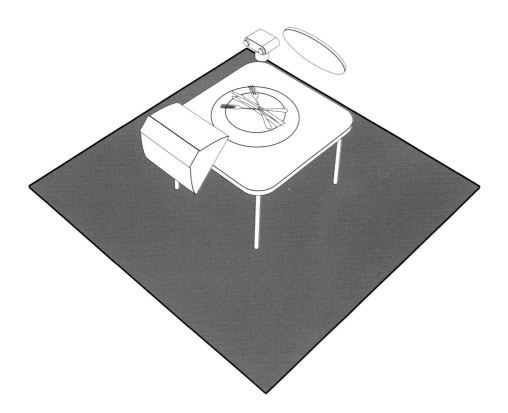

plan view

asparagus and forks

Improvised reflectors can enhance the light provided by one softbox.

This classical-looking image is part of a series taken for German fashion magazine Amica. Colour was the important element in the brief. Photographer Joachim Baldauf used a single star-shaped softbox to the left of the camera, with three reflectors placed around the subject as closely as possible without being in the shot. A white reflector was used on the left and black ones were used to the right and over the top. The grey background was placed 3m behind and was not lit directly. The colour was flattened further at the printing stage, to give it a 1950s feel.

(person) Joachim Baldauf
(client) Amica magazine, Germany
(use) Editorial
(format) 6 x 7cm
(lens) 105mm
(film) Agfa Optima 100
(exposure) f/8 at 1/30sec
(lighting) Electronic flash

plan view

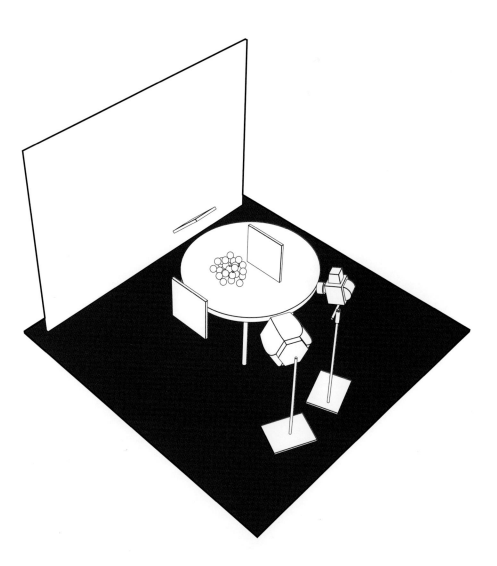

cherry tomatoes

Restrained use of light coupled with carefully placed reflectors produces a beautiful, painterly image.

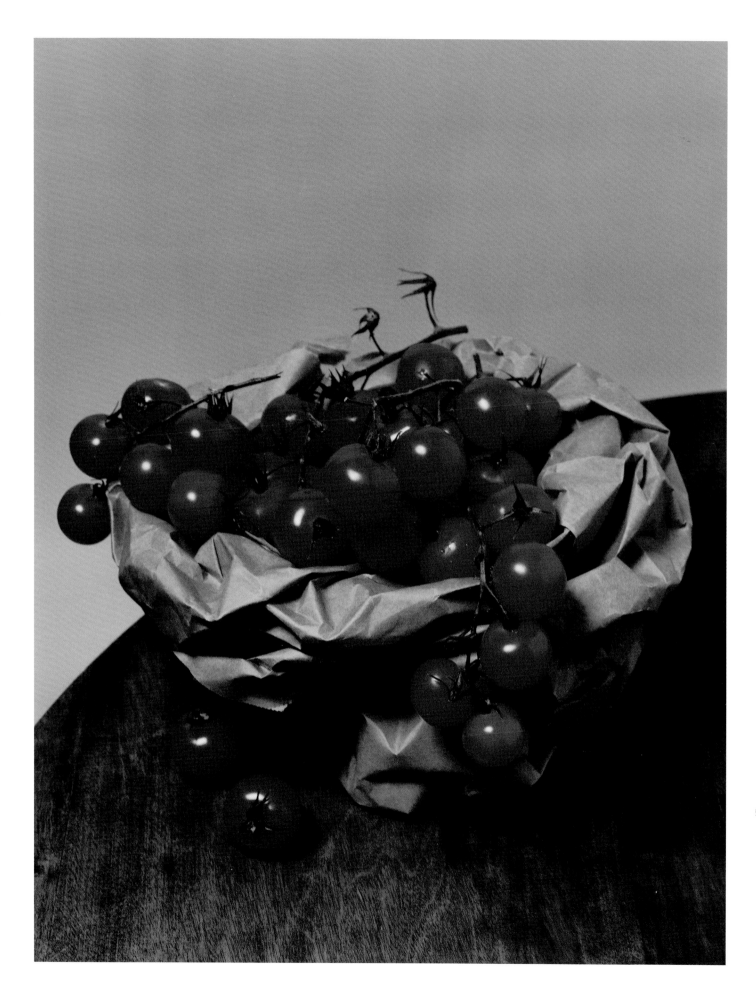

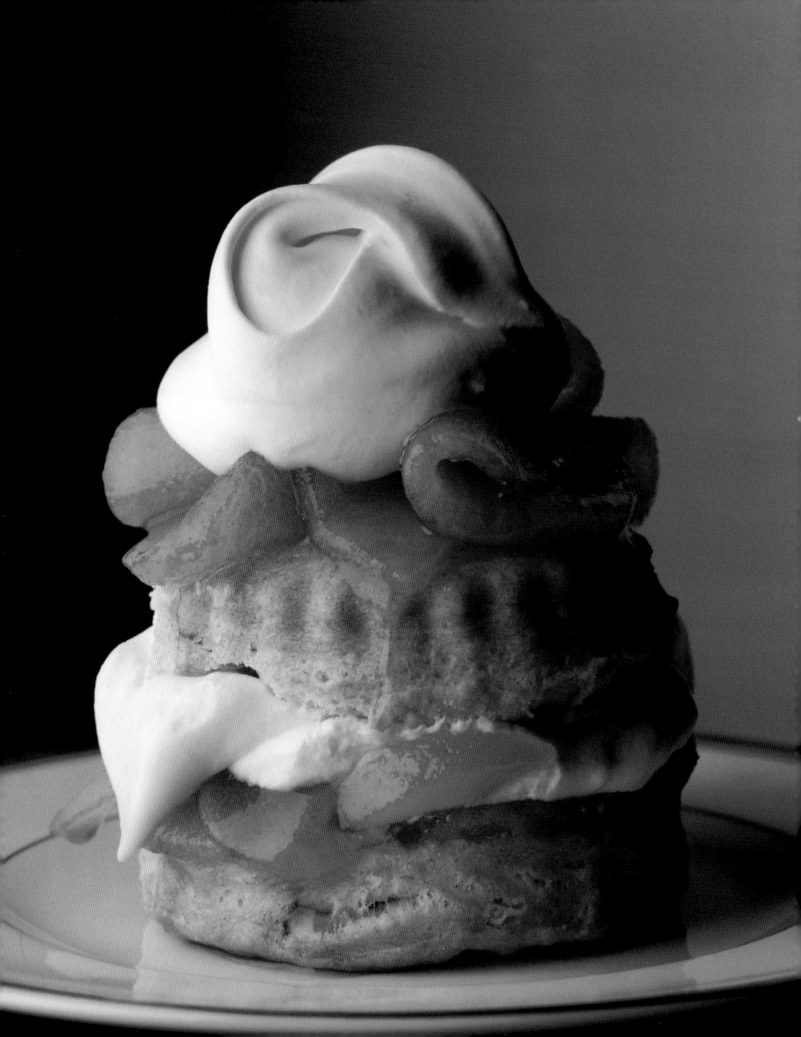

'This is a classic shot,' says Jean Cazals, 'with light against dark and dark against light.' The illumination comes from just one softbox, over to the left. Cazals deliberately chose a tall, narrow version so he could limit exactly where the light fell. A black flag to the left of the light prevents it falling onto the grey background close by, yet allows it to reach the background on the other side, making it lighter. The softbox was positioned so that its top was no higher than the top of the scone – preventing light going over the top and so leaving plenty of texture in the cream. No reflector was used on the right.

Jean Cazals
Sainsbury's magazine, UK
Editorial
6 x 7cm
180mm macro
Fujichrome Provia 100
f/11 at 1/400sec
Electronic flash

plan view

apricot scone

55

One light, used with skill, is sometimes all you need.

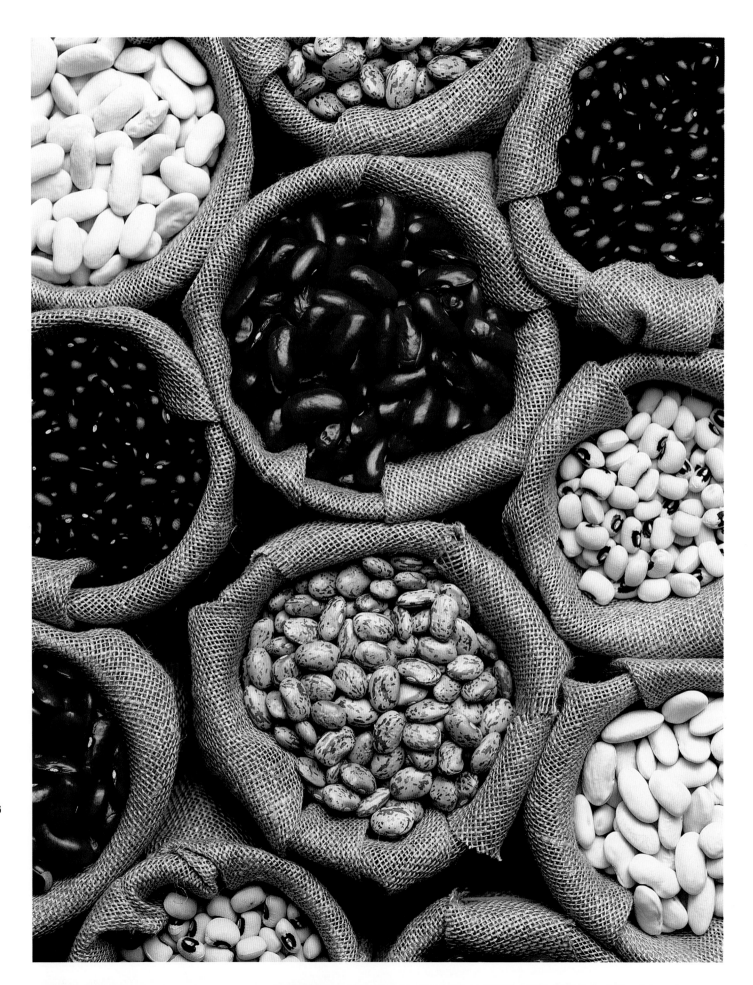

This shot appears as if it could have been taken on location in a market somewhere exotic, but in fact it was set up in the studio to create a series of stock images in a controlled setting. The various pulses were bought from a local supermarket, and the photographer made the containers out of a length of hessian cut into squares and then folded.

The containers were placed on the floor. To mimic a daylight effect, just a single softbox was used, angled down with the top edge of the softbox nearly touching the camera. 'I tend to use just one light for subjects like this,' says Frost. 'The softbox is huge in relation to the size of the arrangement, and it swamps the whole of the set with light – so no second head is required.' The result has a sunny feel to it.

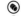 Lee Frost
Personal project
Stock image
6 x 7cm
135mm macro
Fujichrome Velvia
f/6 at 1/30sec
Electronic flash

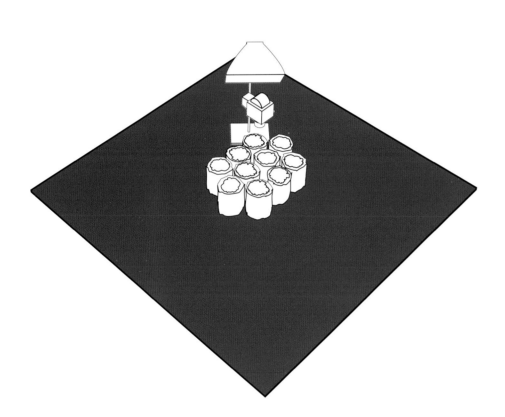

plan view

pulses in bags

A single large light source is all you need with small table-top subjects.

'My lighting is always very simple. For me it's more about the concept and the style. This was a shot about melon soup, so I decided to show what the ingredients were,' says photographer Jean Cazals. 'I included the three seeds at the bottom as a bit of fun. The only light is a large softbox on the right-hand side, about 61cm away, with a white reflector on the left. Shooting against a dark brown table helps project the subject forward.'

(A) Jean Cazals
(⊙) House & Garden magazine, UK
(◉) Editorial
(⊞) 6 x 7cm
(◉) 110mm macro
(▶) Kodak Ektachrome E100VS
(⏱) f/4 at 1/400sec
(◉) Electronic flash

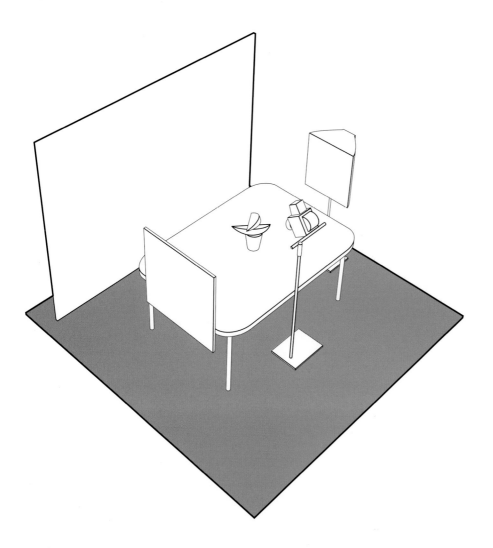

plan view

58 **melon soup**

A black background creates impact.

When Patrice de Villiers is photographing food she normally does some test shots first – to check that everything looks right and the exposure and lighting are correct. 'I use Polaroids like an artist would use sketches,' she says. 'It's just like working through ideas. Sometimes it takes a long time to really get to the picture you have in your mind's eye.' This is not, however, what happened in this image. 'I looked at the test shot and said, "That's it – I cannot do better than that." The cream was perfect. I loved its shape and curves and how it was lit – with the light falling gently and beautifully over it.'

'Test shots sometimes work because you're not trying too hard. There's spontaneity. I just put two dollops of the clotted cream onto a matt Perspex surface and then poured black treacle around it, which formed the beautiful highlight that just makes the image.'

'I lit it with tungsten rather than flash because I love the way tungsten flows over things in a way that flash doesn't. It's much softer. A blue gel was fitted over the only head to convert it to daylight. The light is low and to the left, with just white card for fill-in on the right.'

Patrice de Villiers
Independent on Sunday magazine, UK
Editorial
5 x 4 inch
210mm
Fujichrome Velvia
f/45 at 1/60sec
Tungsten

plan view

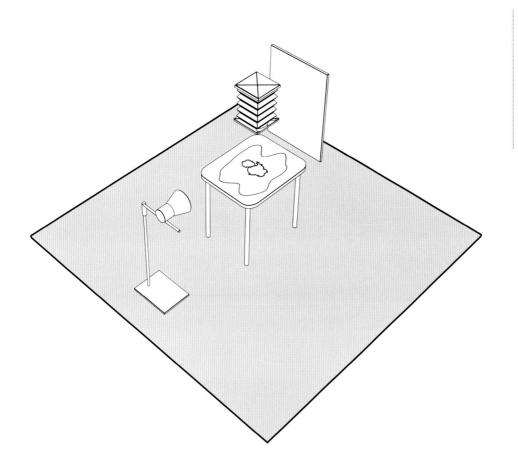

clotted cream

Tungsten lighting gives a softer look.

'I was asked to illustrate a feature on how good seaweed is for you for Health & Fitness magazine,' says de Villiers. 'As it was a Japanese product, I was already thinking about doing something Zen and graphic, but when I took the flat square pieces out of the packet and held them up to the light I saw the fantastic texture, which immediately suggested backlighting. However, it was obvious that I couldn't just photograph the seaweed on its own – people wouldn't necessarily know that it was food. It could be a piece of fabric. The fork was the element needed to make the picture work. I secured it in place using a clamp, with the seaweed hanging behind.'

The seaweed is lit with one softbox fired back towards the subject through the Perspex background. Much care was taken to avoid flare, by masking off any Perspex that wasn't in the frame so as to prevent extra light flooding in. This type of backlighting can be achieved with a lightbox, but this removes the element of gravity which is often necessary for a naturalistic feel.

(A) Patrice de Villiers
(≈) Health & Fitness magazine, UK
(⦿) Editorial
(▥) 5 x 4 inch
(◉) 210mm
(▣) Fujichrome Velvia
(⊘) f/32 at 1/125sec
(◐) Electronic flash

plan view

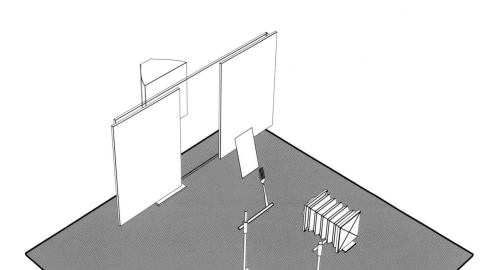

red and green lettuce

'I'd never seen this special kind of lettuce before,' says de Villiers, 'when I picked it up it formed these wonderful strands, and I noticed it had this lovely sea salt on it. Those qualities would not have come out with front lighting – that's not where the interest was. However, when I put light through the back, the shadows that it made when it folded up against itself created interesting patterns. I used a fish fryer through Perspex at the back, with plenty of black velvet over the areas of the light that wouldn't be seen to stop flare. The lettuce strands are hanging from a pole, allowing gravity to give them tension.'

backlighting to reveal texture

With some subjects, the best way to reveal their intricate textures is to light them from behind.

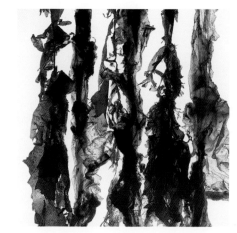

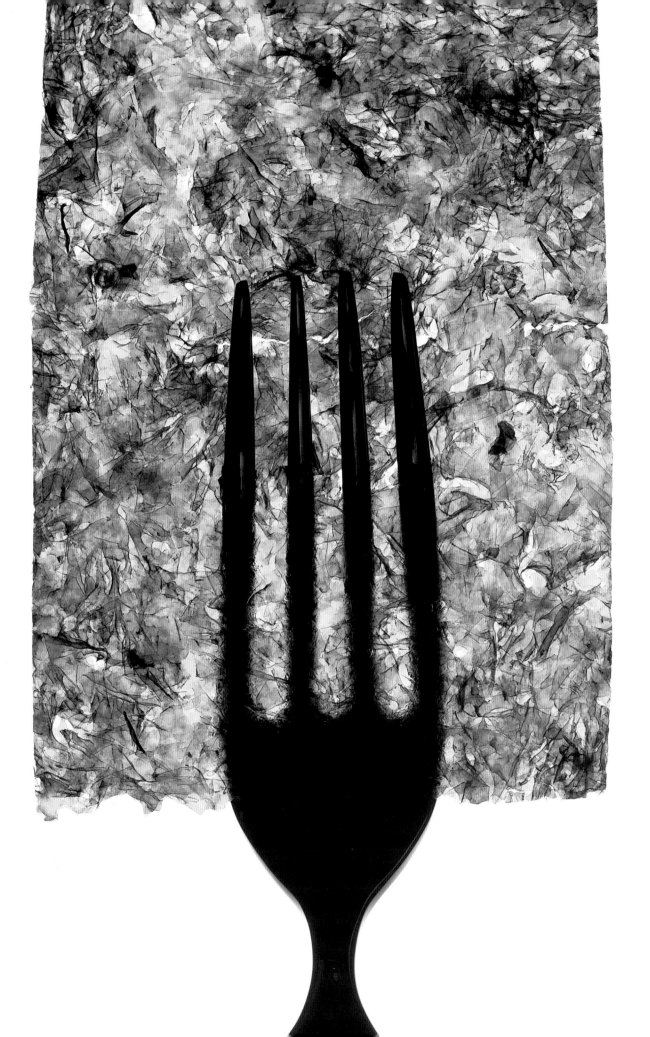

eggs on Jiffy bag

'This Jiffy bag was an ideal background – textured but not too crumpled – and ideal
for a subtle subject such as eggs. For me they're such a simple but photogenic form, and the technique
allows me to pick out just the odd glistening highlight.'

- Jeremy Webb
- Personal project
- Portfolio
- 6 x 4.5cm
- 75mm
- Kodak Ektachrome 160T (tungsten)
- f/11 at 30 seconds
- 10cm torch

light-painting using an ordinary torch

It is possible to improvise specialised techniques without buying specialised equipment.

Although the technique of light-painting is well-known, not many photographers get involved because of the heavy cost of investing in the equipment. But determination will get you a long way, and that's certainly true for Jeremy Webb, who has found a method of producing similar results with a pocket torch he got for free.

His approach is similar to that used with Hosemaster and Lightbrush systems. Working in a darkened room, and having already focused and composed the picture, he simply opens the camera's shutter on the B setting, switches on the torch, and lights various parts of the subject in turn, typically for exposures of 30 seconds.

'The technique's taken a while to learn,' he says, 'sometimes you need to just flick the light on and off, sometimes you can take a broader sweep. You can never guarantee the results, but through experience I've learned how to anticipate largely how it will come out. That said, there have been occasions when the results have been absolutely stunning when I thought they would be pedestrian – and vice versa. It's a technique that depends upon the physical nature of what it is you're photographing. The important thing is to avoid highly reflective areas – such as glazed plates. You can completely ruin a picture if the torch lingers too long. Dark and textured areas sometimes need a lot more light because they absorb so much.'

'The torch I use is a tiny thing about 10cm long which I got free when I applied for a credit card. It suits the job perfectly because it's not too powerful. I stick to just one torch because otherwise it could get too complicated. The only problem is that it costs me a fortune in batteries, because you have to change them every hour, otherwise the power would diminish slightly and the output drop off – and exposure wouldn't be repeatable. Generally I keep the torch between 30 and 45cm away from the subject. If I go closer there's too much light, and if I pull farther back the spread is too wide. I always bracket exposures, taking one picture above and one picture below what I think it should be. Of course, I do try different things with each set-up. Sometimes I'll take the torch down really low, or linger a while longer in a particular place so it comes out brighter. I use a tungsten-balanced film, which seems to give reasonably neutral results without the need for any filters over the lens or torch.'

plan view

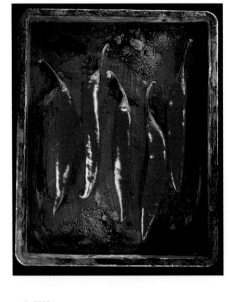

chillies on a tray

'I'm very keen on marrying the right background with the right subject. Here, I felt the blue would work well with the red. Chillies are waxy and reflective, so you have to avoid lighting them too directly. Also remember to put light in-between, or you can end up with them bright outside the edges of the group, and dark in the middle.'

plan view

- (person) Jeremy Webb
- Personal project
- Portfolio
- 6 x 4.5cm
- 75mm
- Kodak Ektachrome 160T (tungsten)
- f/11 at 30 seconds
- 10cm torch

leeks

'Here, I raised the leeks up and was able to get underneath with the torch – so the lighting is more on the edge than the top. I tried a few variations, but this composition, with the two leeks facing in opposite directions, seemed to be one of the best. The background was a painted piece of corrugated board.'

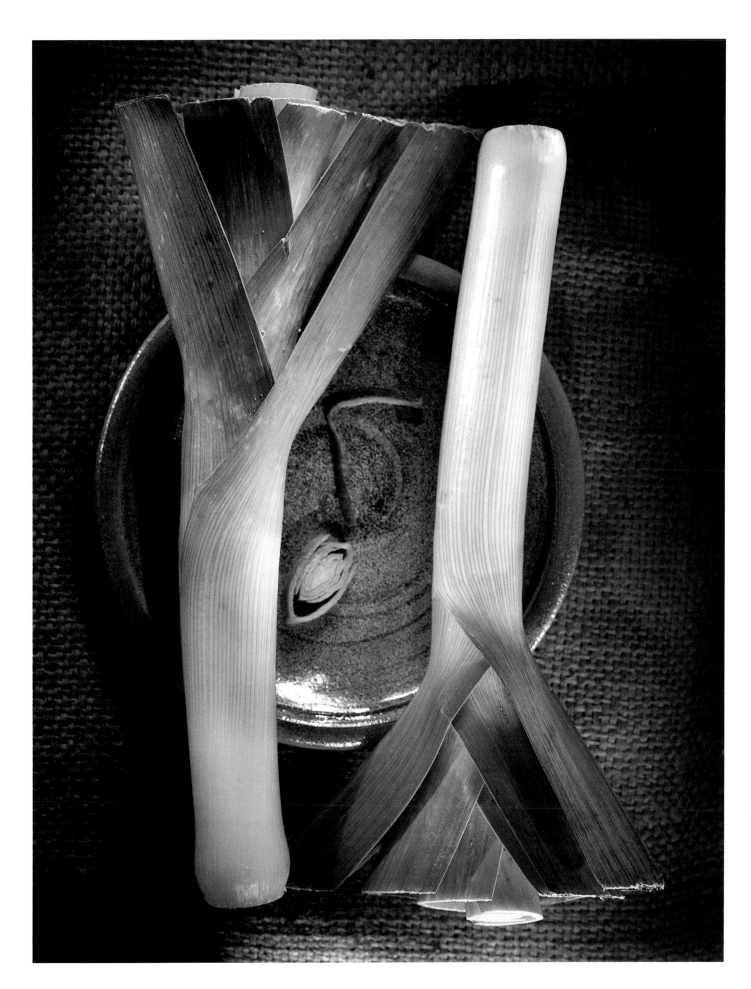

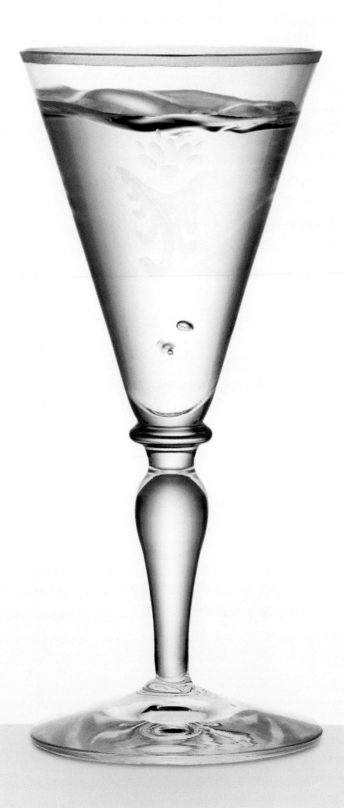

This schnapps glass looks at first sight like a perfectly standard shot – until you notice the movement in the surface of the liquid. This was achieved digitally. The glass was photographed as liquid was poured into it, disturbing the liquid's surface area. The stream of liquid was then removed using a computer, and the background also subsequently added. 'We wanted it to look like a stormy sea,' says Bergström.

The lighting itself was relatively simple, but with an ingenious twist. The schnapps glass was placed on a glass shelf inside a plexiglass tube, which was then backlit by a single flash head in a standard reflector fired through a diffusion screen. 'I try to keep things simple,' says Bergström. 'If something is too dark, I add some more light – if not, I don't.'

Pelle Bergström
Stockholm New magazine, Sweden
Editorial
5 x 4 inch
210mm
Kodak 100 Print
f/22 at 1/60sec
Electronic flash

plan view

schnapps glass

A simple and original approach to lighting glass.

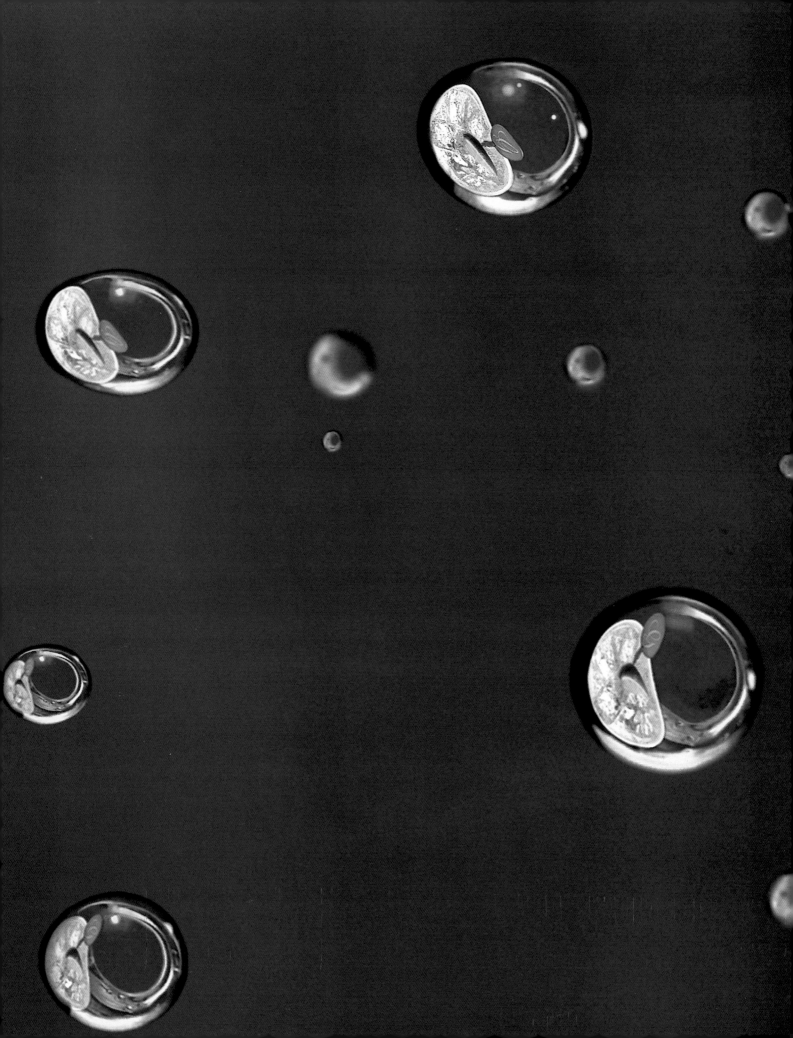

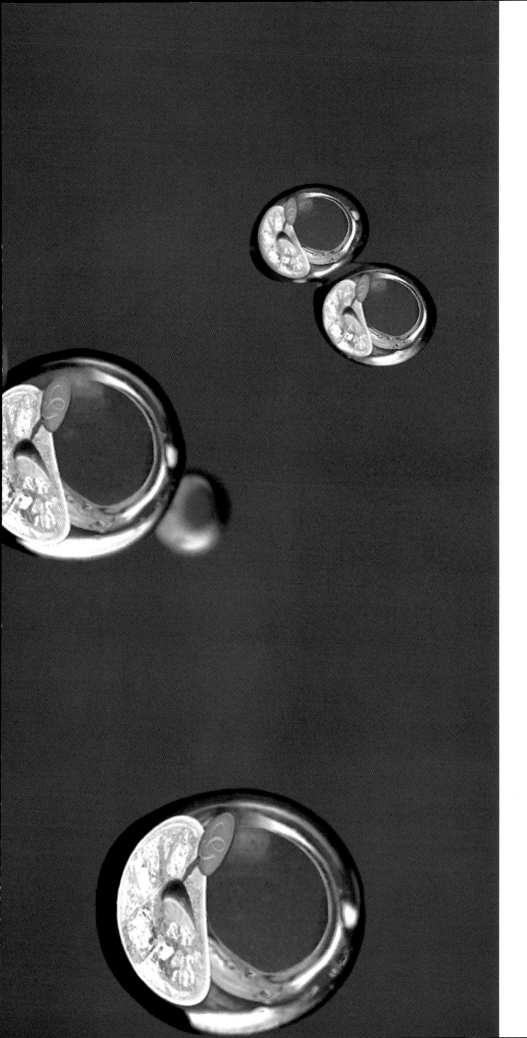

two lights

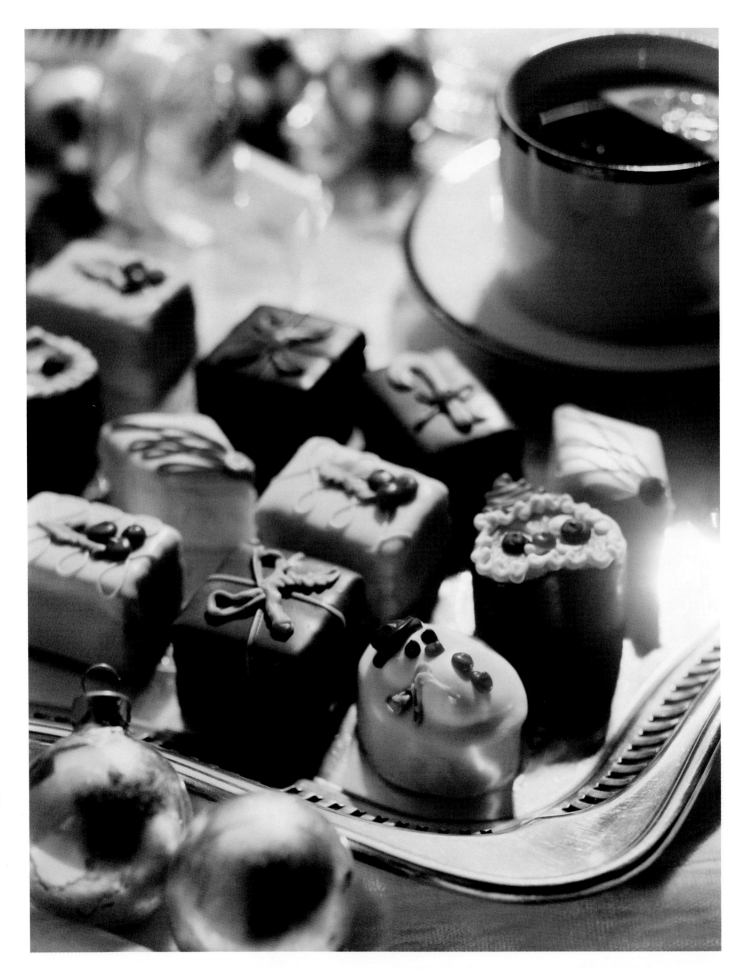

'Because chocolate often doesn't have a lot of texture,' says Becker, 'I tend to use a small light source which helps bring out what ridges there are and also assists in revealing their shape. For this shot I used a bare flash head in a 12.5cm reflector at the top right of the shot. Raising it just a couple of feet above the table throws the shadows forward from the teacup, and gives some welcome highlights on the very dark chocolate. That light also produces the "blown-out" area on the silver tray which has a slight flare to it. I did some different versions without this, but for me the flare works, evoking the bright, sunny effect I was after.'

'As a general fill to control the contrast and hold details in the hard shadows I placed a boomed softbox over the top of the set. The final element was a 76 x 101cm reflector card at the bottom left, to bounce light into the shadow areas and create the highlights in the silverware at the front of the frame.'

Becker concludes, 'I set a fairly wide aperture of f/5.6 so the image was sharp in the front but going soft in the back – and I also used the movements of the camera to enhance that effect.'

- Rick Becker
- Kitchen and Home magazine, UK
- Editorial
- 10 x 8 inch
- 360mm
- Kodak Ektachrome E100S
- f/5.6 at 1/125sec
- Electronic flash

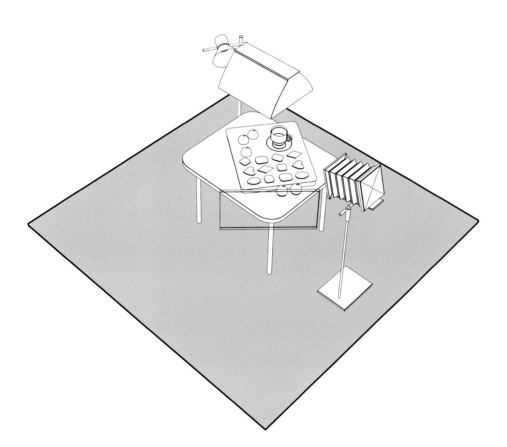

plan view

working with chocolate

'Some photographers like to use a hairdryer when shooting chocolate, to produce a melted, glistening sheen. I prefer a satiny kind of look, which I get by using a dry camel-hair brush. This also helps eliminate any fingerprints and inperfections there may be in the chocolate.'

chocolates on silver

Using a small light source can help bring out the texture of chocolate.

This picture of olive oil bread was taken for a book on bread-making, but, of course, you can't tell there's oil in the bread by looking at it. De Villiers' solution, therefore, was to include some oil in the picture as well.

'The bread was incredibly sculptural,' she says, 'and that was the starting point for me. I arranged the bottles to make an L which I then broke up with the round shape of the bread. The smoothness of the bottles also makes a wonderful counterpoint to the textured surface of the bread.'

The contrasting nature of the subject elements meant that both front and backlighting were required – and care had to be exercised in balancing the two. 'Photographing oil is different from photographing a liquid with colour in it – it's viscous and has greater density, which meant I could pump more light through it and it would retain its depth of colour.' That was important because she wanted the background to be pure white to reinforce the graphic quality. A single softbox was fired back through a Perspex screen behind the subject, while the main light was placed up on the right-hand side.

Patrice de Villiers
Independent on Sunday magazine, UK
Editorial
5 x 4 inch
210mm
Fujichrome Velvia
f/32 at 1/125sec
Electronic flash

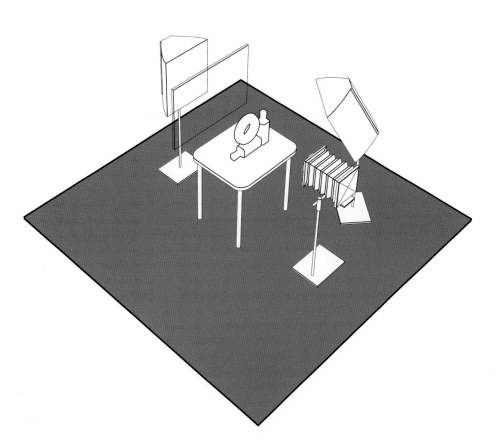

plan view

avoiding flare

'You need to take care to avoid flare when you're backlighting Perspex to produce a white background, as sharpness will be lost and the colour desaturated. The secret is to mask down the Perspex background with black velvet on all sides.'

oil and bread

Combining backlighting and frontal lighting in the same image requires careful control over exposure.

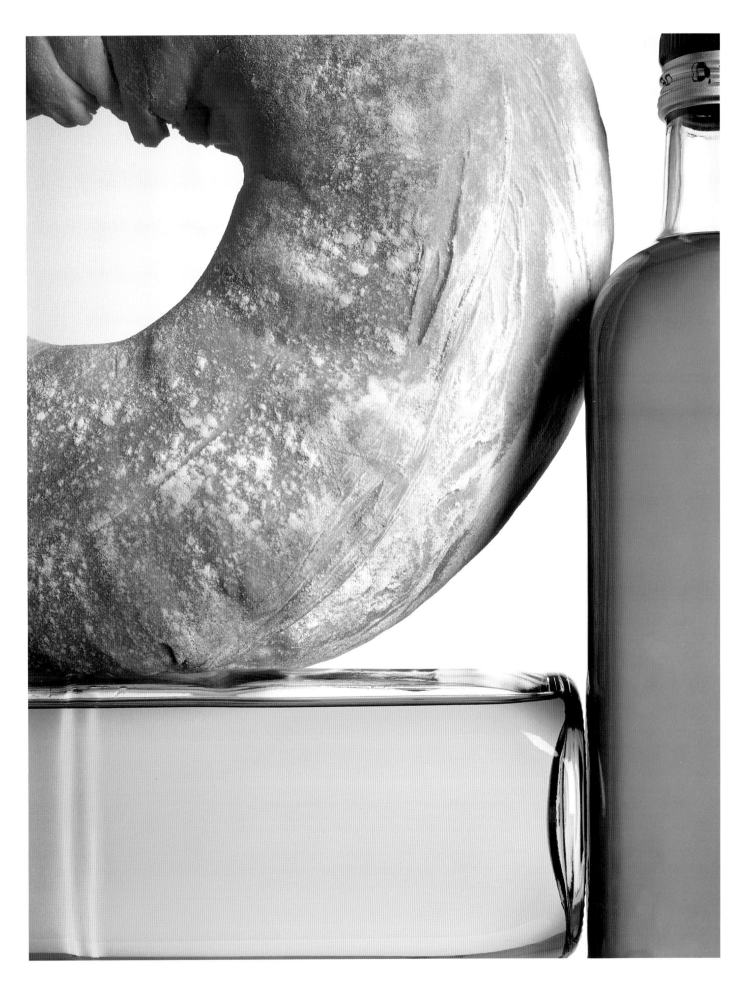

food and fashion

The innovative approach of Joachim Baldauf

Food doesn't have to be still life. It can be integrated successfully with other genres of photography – as here, where fashion and food were blended to produce a feature called 'The Dish' in Wallpaper* magazine. 'The brief was about "presenting food for your lover",' says Baldauf, 'and my idea was to style the people like the food – with the clothes, models, hair, style and background all matching.'

For these shots there was not only a food stylist, but also a fashion stylist, hair and make-up and a set stylist – not to mention Baldauf's own assistant. Co-ordinating all of these people to ensure the models were ready at the same time as the food – which was being prepared in the studio – could have been a nightmare, especially as the backgrounds were also being built and taken down as the shoot progressed. But, everyone worked as a team and so it all ran like clockwork (despite one of the models not arriving because of problems with her papers and a replacement having to be organised at short notice).

For all of the pictures, the lighting was essentially the same: a main light for the model and another light on the background, with large white and black reflectors added as necessary. 'I work a lot with reflectors,' says Baldauf. 'I keep the light as it is but change the detail and emphasis by the way I use the reflectors. I like to prepare everything carefully, and then when it is ready I shoot really fast. Sometimes I only take ten to 15 minutes for each image, although when you're combining food with fashion it can take a little longer.'

linguine with langoustines

'We had a problem with this shot because the orange from the arch was reflecting onto the skin of the model. Although I didn't want to get rid of it completely, because then it wouldn't look real, I reduced the amount of reflection with a black painted reflector on the left-hand side. The main light was a small diamond-shaped softbox up high to my left, and the light on the background was fired into an umbrella.'

Joachim Baldauf

Wallpaper* magazine, UK

Editorial

6 x 7cm

105mm

Agfa Optima 100

f/8 at 1/30sec

Electronic flash

plan view

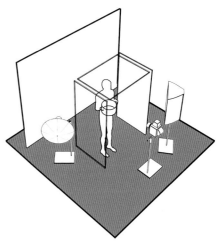

coq au vin

'This was a difficult shot because the model had lots of hair under his eyebrows, so we had to make the light a little softer, bringing it lower and slightly more central. Large black reflectors were placed both sides of the subject. They give more texture to the skin, and you see everything. But that is not always a good thing, that's why I always do a proper casting for models, to make sure their skin is good enough. Here it works well because the model has such a strong character.'

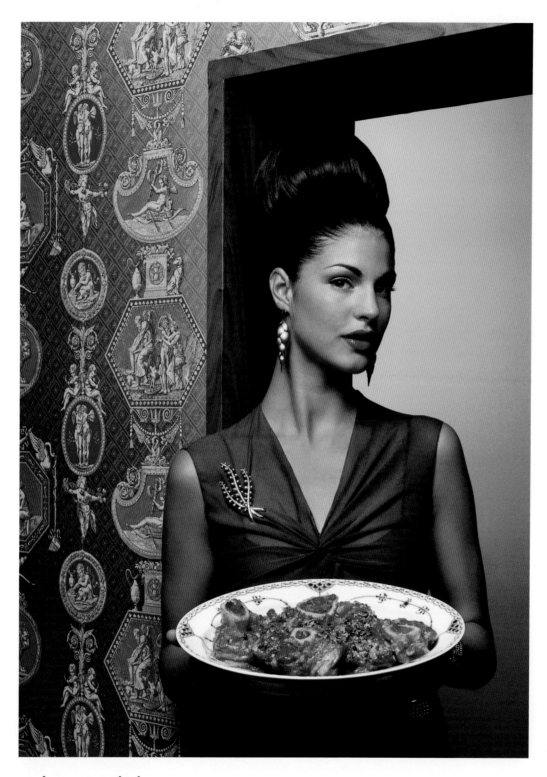

asian model

The main difference with this shot is that because the model is Asian, and has such glossy hair, it was necessary to use a third black reflector – placed over the top as a 'ceiling', to reduce the reflectiveness. Otherwise the lighting is essentially the same, with a small softbox up and to the right, a second head fired into a brolly lighting the background, and black reflectors both sides of the model.

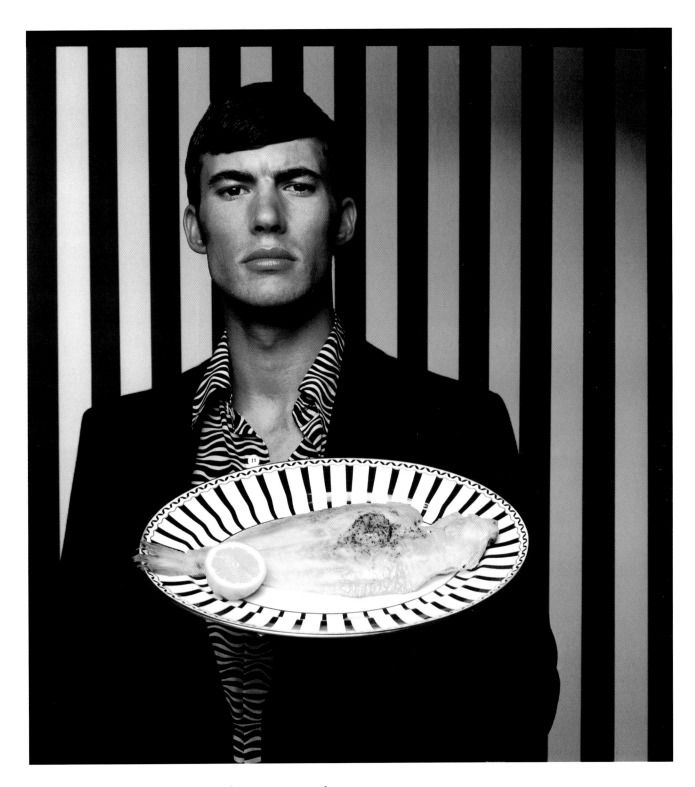

lemon sole

'We were getting reflections from the black & white wallpaper and the model's oily complexion in this shot. This was remedied by placing the softbox as the main light more centrally, and by making a cross on it with black gaffer tape to diffuse it. The background was lit by a head fired into a brolly, and there were black reflectors both sides.'

This is a straightforward image, but one which works well for a whole host of reasons – the clear separation of the foreground subject from the background; the harmonious composition created by choosing material in the same area of the colour wheel; the freshness of the tomato indicated by the 'just washed' look of the water droplets – and the contrasting dry texture of the cloth.

The lighting, also, is clean and crisp, with just two HMI heads used with the digital camera back. The shot is essentially backlit, with the main light at the top right, pointing towards the camera and fired through a diffusion screen. 'What clients want is something that looks fresh and tasty,' says Webster, 'and backlighting helps achieve that.' Directly opposite the main light, at the bottom left, is a second head fitted with a softbox and powered down to give just sufficient output for the desired lighting ratio.

- ⊛ Paul Webster
- ⊗ Granada services, UK
- ⊘ Point-of-sale
- ⊜ 5 x 4 inch
- ⊚ 300mm
- ⊟ Digital capture
- ⊘ f/11 at 1/50sec
- ⊘ Continuous HMI lighting

plan view

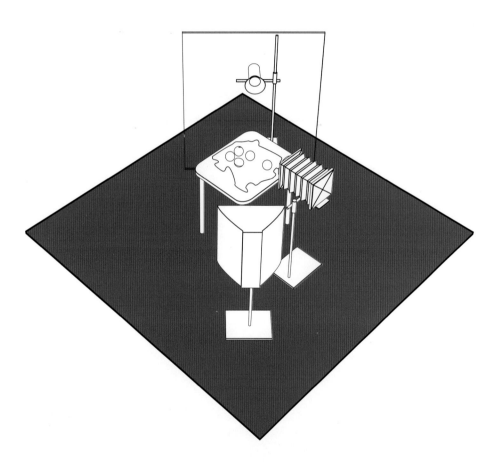

fresh tomatoes

Harmonious colours and foreground/background separation produce a strong, simple image.

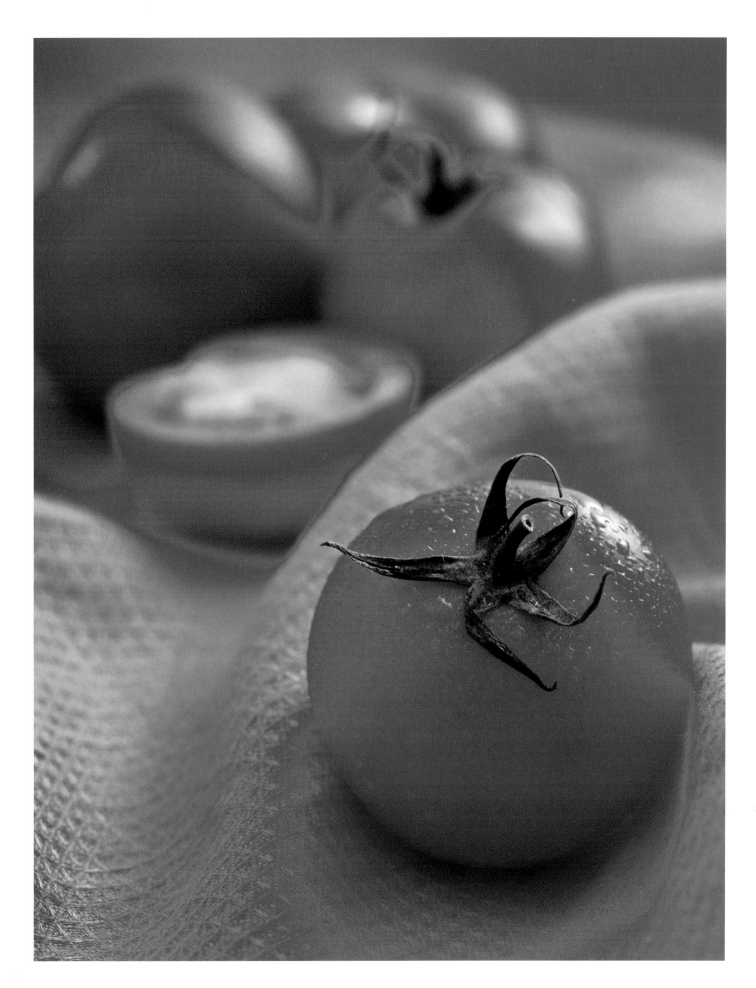

How would you go about creating this shot? Wire all of the items together? Shoot them individually and combine them on the computer? Paul Webster's approach was simple and effective. He placed them on glasses resting on the painted wooden backdrop below – all except for the fork and the sausage, which were clamped – and shot them from above. This lifted everything 15cm up in the air and, because the glasses were clear, plain tumblers, they didn't throw any shadows.

The main light was positioned on the left-hand side and fired through a screen to soften it. A fill-in light was placed diametrically opposite to control the contrast.

👤 Paul Webster
🔄 Waterstones bookshops, UK
◑ Poster
📷 5 x 4 inch
◉ 360mm
▣ Digital capture
🕐 f/16 at 1/40sec
💡 Continuous HMI lighting

plan view

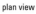

82 # food tower

Imaginative use of glasses as stands makes it easy to produce an eye-catching image.

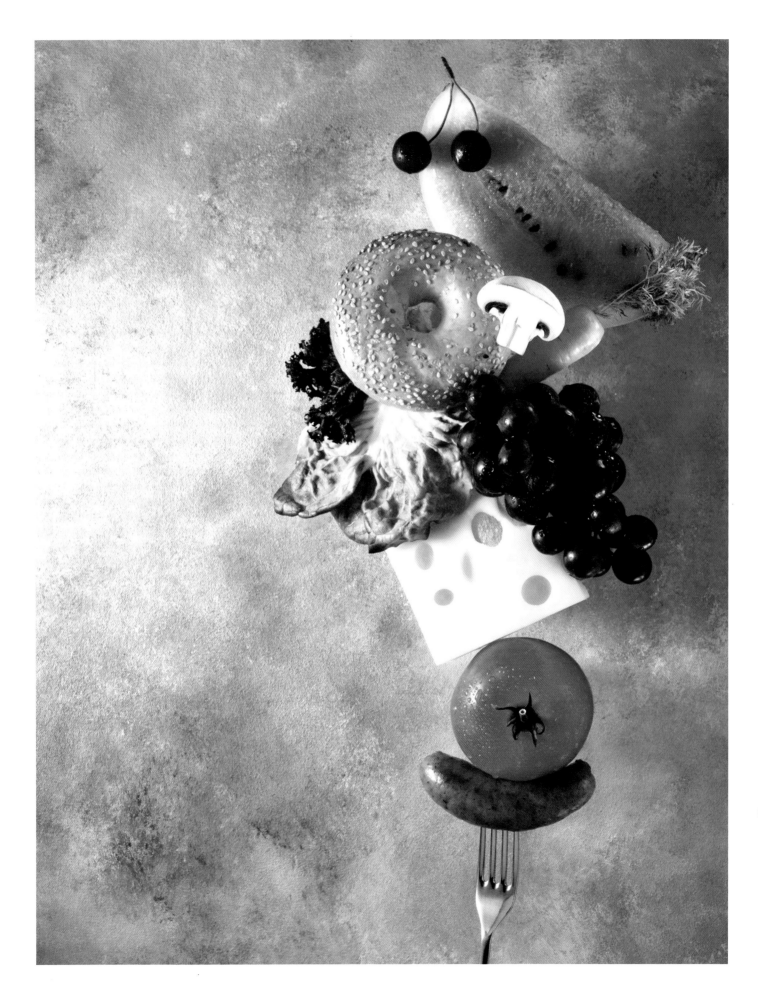

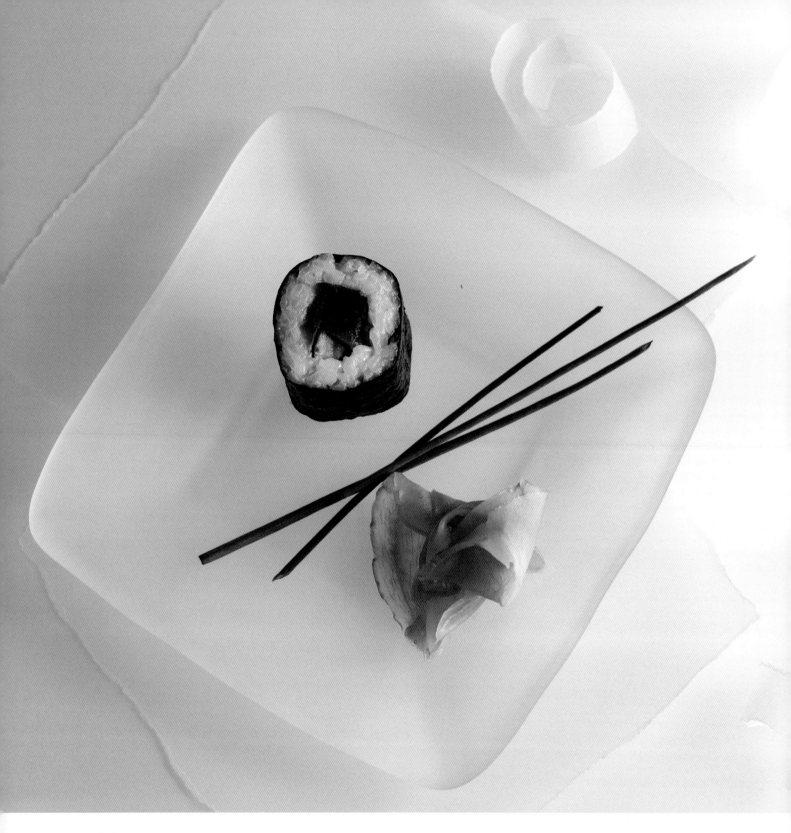

sushi

Ultra-soft lighting can be produced by lighting indirectly and using tracing paper.

⊛ Paul Webster
⊘ Personal project
◉ Portfolio
⊛ 5 x 4 inch
◉ 360mm
⊕ Digital capture
⊙ f/11 at 1/40sec
⊙ Continuous HMI lighting

plan view

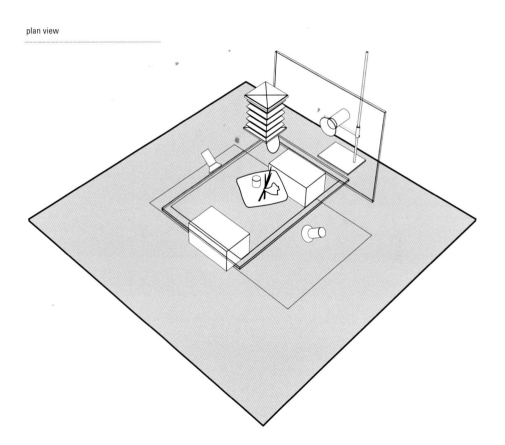

Having ended up with some A3 sheets of tracing paper after a shoot, Webster began to wonder how he might make use of them photographically. 'I started playing around with diffused light, looking for a very soft feel,' he says, 'and I came up with this lighting arrangement. There's a sheet of glass covered with tracing paper resting on two large wooden crates. Underneath it is a white sheet of card onto which two HMI lights are angled at 45 degrees. The reflected light coming up through the tracing paper is thus extremely soft. I already had the translucent plate and vase, and sushi, being delicate, seemed the natural subject to shoot. The only other light is a third HMI head fired through a diffusing screen on the right-hand side.'

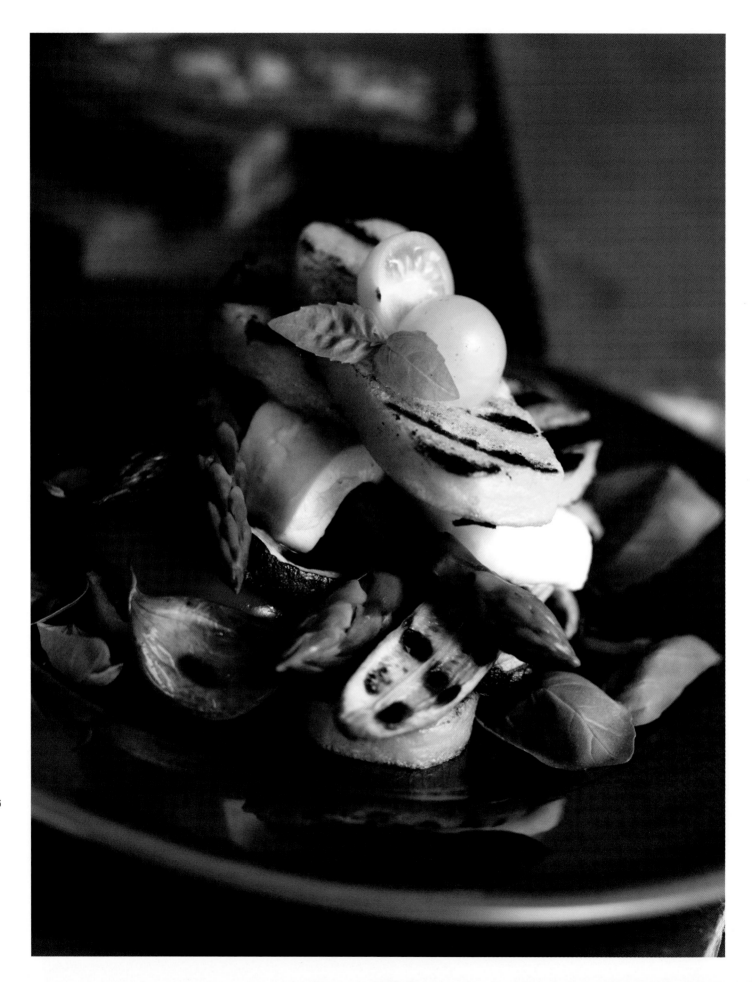

One of the most striking and unusual things about this food shot is the choice of plate. Instead of the more commonly used white, which seems to project the food forward, the dark blue creates an atmosphere that's altogether more low-key, so that the plate and food become a harmonious whole. Despite this, the plate was a nightmare to work with, recalls photographer Paul Webster. 'It had a very high-gloss finish, and just the lightest touch left a mark – and we were constantly having to clean it to avoid fingerprints being seen.'

This was exacerbated by the sidelighting used – with an HMI head directed through a softening screen on the right-hand side and a second head similarly arranged providing fill-in from the left. Making an arrangement of quarry tiles produced the out-of-focus interest in the background. To prevent them going too dark, a silver reflector was angled just behind them to pick up the light from the two heads and bounce some of it back down onto the tiles.

ⓧ Paul Webster
◉ Personal project
◉ Portfolio
◉ 5 x 4 inch
◉ 360mm
◉ Digital capture
◷ f/11 at 1/40sec
◉ Continuous HMI lighting

plan view

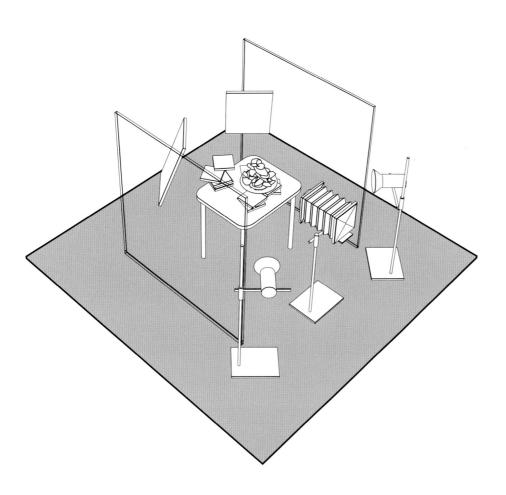

piled polenta

A blue plate plays a part in creating the overall mood.

- Paul Webster
- Personal project
- Portfolio
- 5 x 4 inch
- 300mm
- Digital capture
- f/11 at 1/50sec
- Continuous HMI lighting

plan view

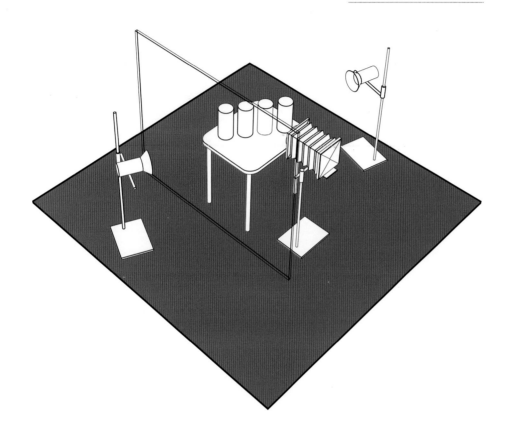

stella artois

Blasting a light between cans creates a dynamic feel.

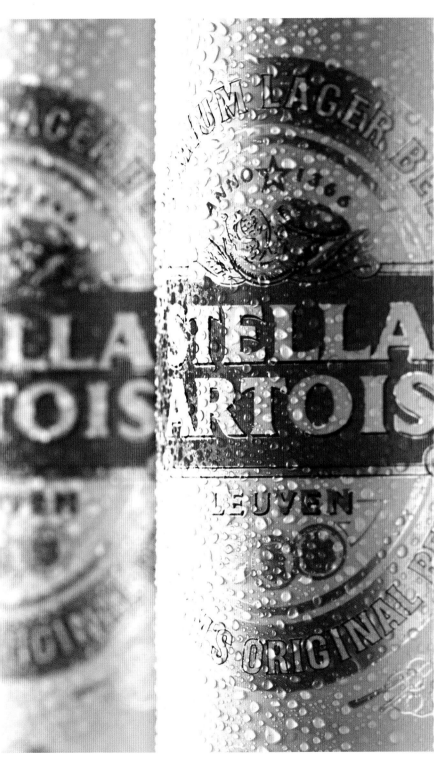

When photographing products, one of the main aims is to concentrate the viewer's attention on the important part of the subject. This is normally the brand name. An effective way of doing that is to make it stand out from its surroundings – as here, by the use of differential focus and limited depth-of-field. What also works well here is the way the lighting seems to burst through from between the cans. This was achieved by firing the light at them from behind – a tungsten HMI light was diffused through a diffusing screen. A second head, facing the main light, was used to balance the lighting ratios.

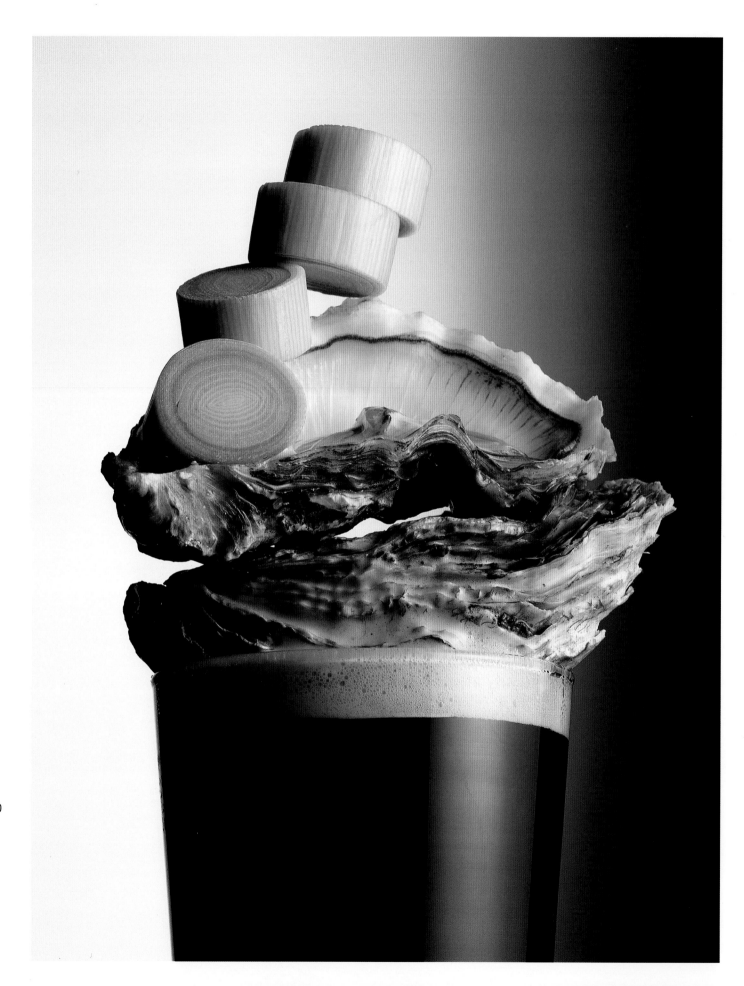

This picture was part of a series the photographer was doing on different cities, including food associated with the area – this example illustrates Dublin. 'Guinness and oysters are obvious Dublin things,' she says, 'but the leeks were a welcome inclusion. The oysters and the Guinness are essentially monochromatic, but it was great to have the rounded shape and soft colour of the leeks. The main question was how to bring these disparate objects together in an interesting way, and I decided to balance them on each other to create a little tension.'

The lighting on the subject is straightforward: just a square softbox fired through a diffusion screen, to prevent it being too hard. What makes it work, though, is the hard graduation of tone in the background. This was achieved by flagging off the light behind, which is being directed through a Perspex screen. How far the flag is away from the light determines how hard the graduation is. Bringing it close to the light source, as here, creates a sharp transition from light to dark.

- Patrice de Villiers
- The Weekend Times newspaper, UK
- Editorial
- 5 x 4 inch
- 210mm
- Fujichrome Velvia
- f/32 at 1/60sec
- Electronic flash

plan view

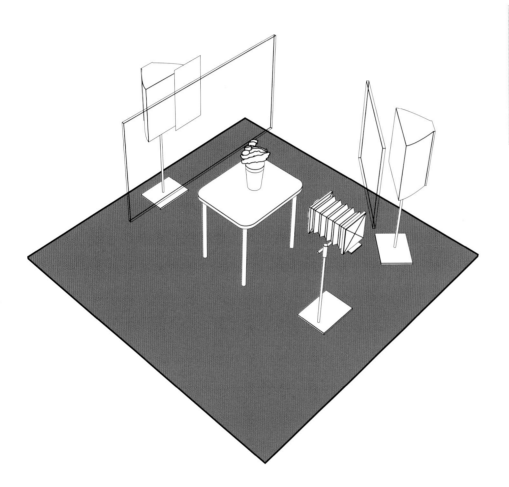

diffusion screens

'I make up my own screens of varying sizes using special diffusion material. The further the light is to the screen, or the screen from the subject, the softer the light will be.'

guinness and oysters

91

Graduating the background lighting can add extra interest to the shot.

(symbol) Paul Webster
(symbol) Tony Stone picture library, UK
(symbol) Stock image
(symbol) 5 x 4 inch
(symbol) 300mm
(symbol) Digital capture
(symbol) f/11 at 1/50sec
(symbol) Continuous HMI lighting

'The more natural the lighting looks, the happier I am,' says Paul Webster. 'I would like every shot to look as if it's lit from one light source. When I use more than one light, it's simply to balance the ratios. I don't like multiple shadows, and I don't like hard lighting.' The practical application of this philosophy is evidenced in this delicate and elegant shot, which very convincingly looks as if it were captured spontaneously outdoors on a sunny day – when in fact it was carefully constructed in the studio.

Two lights were used. The main illumination comes from the left, provided by a continuous output HMI head directed through a softening screen, with a complementary head on the right providing fill-in. The inspired choice of the roofing tiles to support the garlic also plays an important part in producing an authentic-looking stock image.

plan view

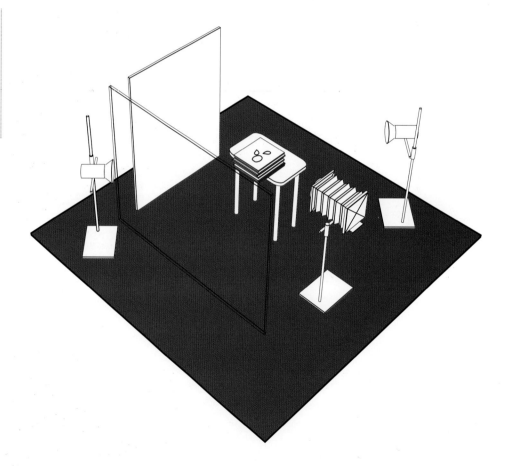

92

garlic on slate

The best lighting recreates the qualities of daylight.

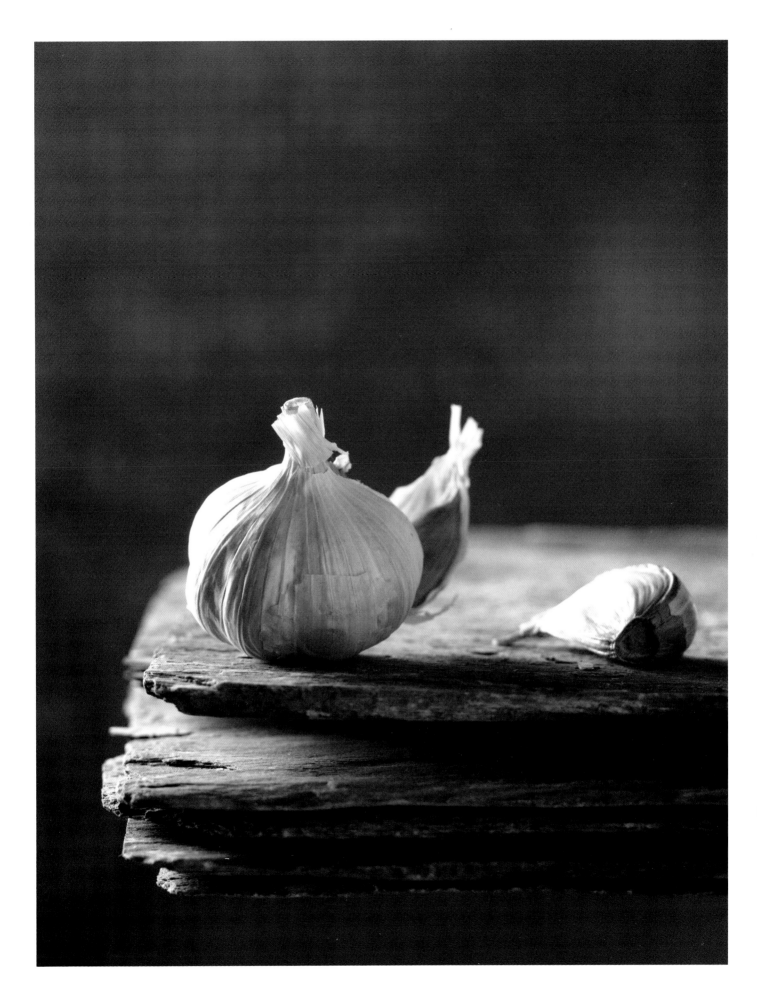

chilli, rice and garlic

Introducing brightly-coloured graphic elements can give images added richness.

test shots

'If the time scale of the shoot allows me to do a test film, then I generally do. The way I shoot is very specific and it's very fine-tuned. I use black & white Polaroid Type 55 film to gauge exposure, and put a magnifier on the negative to check focus.'

Patrice de Villiers
Sunday Telegraph magazine, UK
Editorial
5 x 4 inch
210mm
Fujichrome Velvia
f/45 at 1/125sec
Electronic flash

plan view

'For this shot I took elements from a particular recipe the food writer had done,' de Villiers explains, 'and put them together in an interesting way, with the garlic on top of the chilli and the rice. To make the shot more sumptuous, and to pull out the red of the chilli, I introduced some purple handmade Japanese paper.'

'The rice is sitting on a table, and the handmade Japanese paper is in the foreground. I took a low viewpoint because I didn't want a horizon line. The background is a flash striplight that has coloured gels on it. It was a painstaking process to match the background to the foreground, and I kept adding and taking off gels until I got the right combination. Because the chilli was reflective, I wanted a soft light, and fired the softbox not only through Perspex but a trace diffusion screen as well.'

95

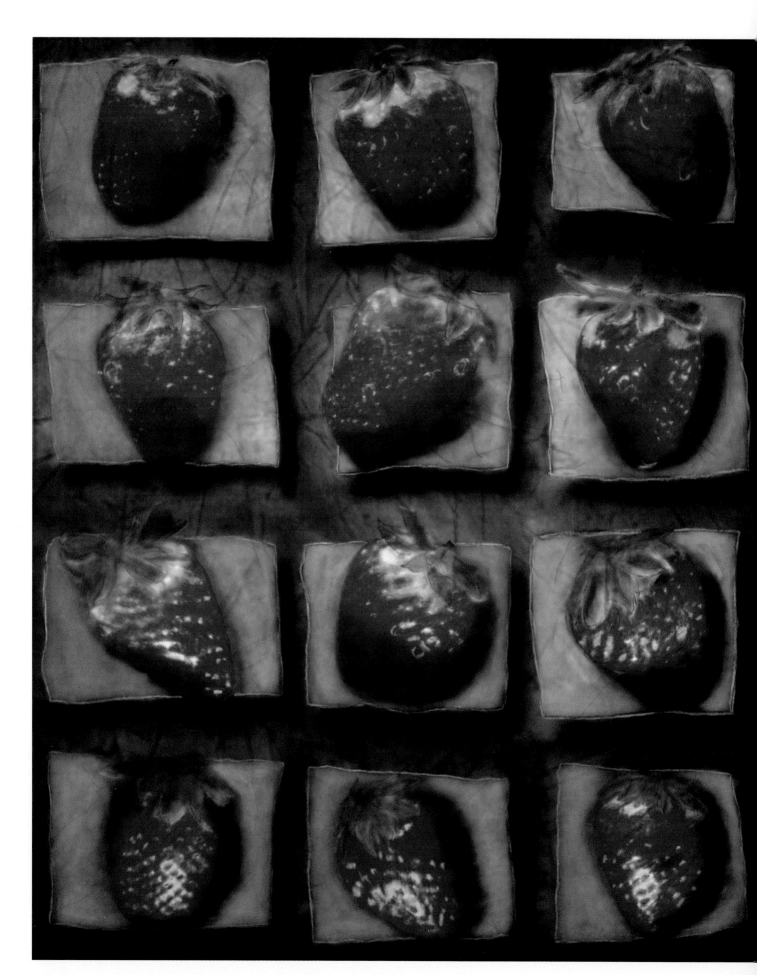

'This was one of the first shots I did which involved placing things inside the bellows of the camera,' says New York photographer Jay Corbett. 'I used a floral acetate, which produces a random pattern of colour modulation and subtle variations in how much light falls onto different areas. My aim was to create a painterly, textural picture with an "Old Master" quality to it. The background is some linoleum which I had in the studio and which I really liked. I broke it up into small pieces. These were then raised up on small plexiglass cubes. The strawberries are definitely not designer strawberries. They were out of season and they're kind of beat up, which I thought was perfect for this kind of treatment.'

Just two lights were used, both tungsten. They were fitted with blue filters that removed most, but not all, of the warmth of the heads. One was at the top left, producing the shadow and the other at the bottom right, providing fill-in. Both were angled down at 45 degrees. Overall fill, and the glisten and shine on the strawberries, came from a 1.2 x 2.4m card over the top of the set, with a hole in the middle for the lens to see through.

 Jay Corbett
Personal project
Portfolio
5 x 4 inch
180mm
Fujichrome Provia 100
f/22 at 4 seconds
Tungsten

plan view

strawberries

Placing acetates in the bellows of a studio camera creates a painterly feel.

'For me photography is about observation,' says de Villiers. 'You hope to find some quality in the subject which maybe nobody else has noticed. You bring your personal sensibility to it and try to turn the ordinary into a work of art. For most of my editorial food shots I go and get the things myself. I don't use a stylist. That's because potential subjects have their own character, and finding the right sprig of sage, chilli or runner bean is crucial – if I'm the one shooting it has to be me that chooses, because it is all in the eye of the beholder. You should always look at things and then decide how you are going to light them – rather than imposing a technique onto the subject, whether it's appropriate or not.'

'What's fantastic about this purple sage are the lovely hairs – and to pick them out I needed to backlight it a little. But I also wanted some light falling onto the face of it so you could see the front. What I did, therefore, was to move the light around, take a look at it, and when I thought I'd got it right I started shooting. What I ended up with was a square softbox to the left and slightly behind.'

'The sage is being held up with a satay stick stuck up through the stem, and that is being held with a clamp. The plant was on the set for quite a while, and I kept it alive by wrapping wet kitchen roll around the bottom, so it was still drawing some kind of moisture.'

'The background is a striplight fired through Perspex. I use Perspex because it creates a soft, diffuse light and it's easy to graduate. Here, I have a slight graduation going from left to right – which is a standard still-life way of working. With the darkest part of your subject matter on the left-hand side, it makes sense to have the lighter part of your background behind it.'

(人) Patrice de Villiers
(杂志) Sainsbury's magazine, UK
(书) Editorial
(相机) 5 x 4 inch
(镜头) 210mm
(胶卷) Fujichrome Velvia
(时钟) f/32 at 1/125sec
(灯) Electronic flash

plan view

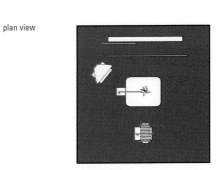

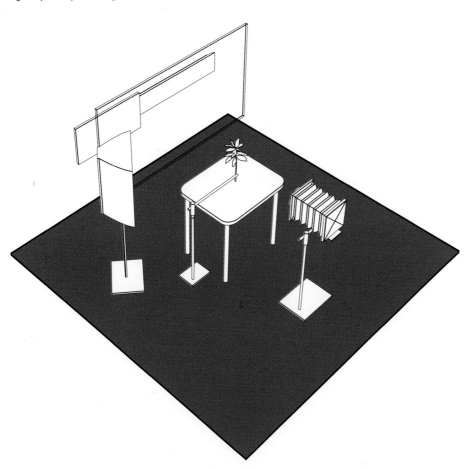

purple sage

Choosing the perfect example of a subject is as important as lighting it to its best advantage.

runner beans

'I didn't have an idea for this picture until I went to get the runner beans themselves. When I picked them up I realised how sculptural they were. As you hold them up against the light you also get a little see-through of the beans inside. By backlighting the beans and keeping the background dark I was able to show them in a way that I thought was interesting.'

- Steve Allen
- Picture library
- Stock image
- 6 x 7cm
- 37mm
- Kodak E100SW
- f/22 at 1/400sec
- Electronic flash

plan view

cans of drink

Careful lighting is required when using a fish-eye lens.

The secret to getting great results with a fish-eye lens is to go in close to your subject – as in this shot, where the front of the lens is just 25cm away from the cans for a dramatic 180-degree perspective. Of course, having such a wide angle-of-view means you have to take care with the lighting. It's all too easy to include the heads at the edge of the frame, along with your fingers and toes! Using two softboxes, one on each side, angled at 45 degrees so the tops were almost touching, gave the required even illumination without the risk of anything untoward appearing in the picture.

Ice cream is reputed to be one of the most challenging of foods to photograph. It melts quickly, of course, but can also be highly reflective. This picture by Terry McCormick shows how it should be done.

'The background was a sheet of handmade fibre paper,' he says, 'which I lit from underneath with a high-powered blast from a flash head in a standard dish to show up all the detail. There were two sheets of Perspex between the light and the paper to diffuse it. The ice cream and bowl were illuminated by a single head at the top-right corner, also directed through two sheets of Perspex to give ultra-soft lighting. To clean up what little shadow was created, a white reflector was placed at the bottom left – and three shaving mirrors were strategically placed to flip light into the corners.'

Terry McCormick
Personal project
Portfolio
10 x 8 inch
360mm
Fujichrome Provia 100
f/45 at 1/60sec
Electronic flash

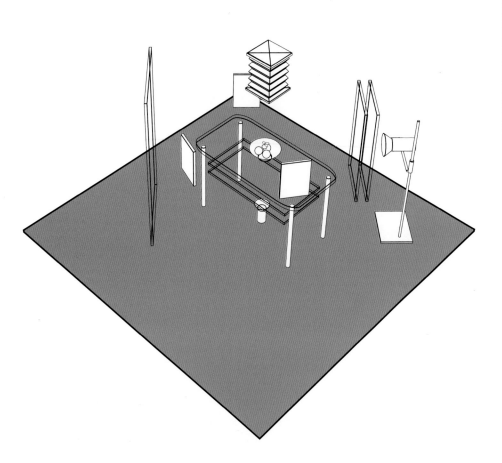

plan view

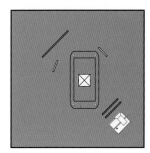

working with ice cream

'You need to work very, very quickly with ice cream. The easiest way is to ask the home economist to do a mock-up, use this to get all the lighting right and arrange the composition. Then, when the art director is happy, do the scoops of ice cream you intend to photograph and just go for it – you don't have time to mess around. For obvious reasons you should switch all your modelling lights off, and in general keep the ambient temperature down. With ice cream it's better to do the Polaroids at the end. If there's anything you're not happy with, then it's easier to just do another version.'

ice cream

Working successfully with ice cream requires possible reconsiderations of your working process.

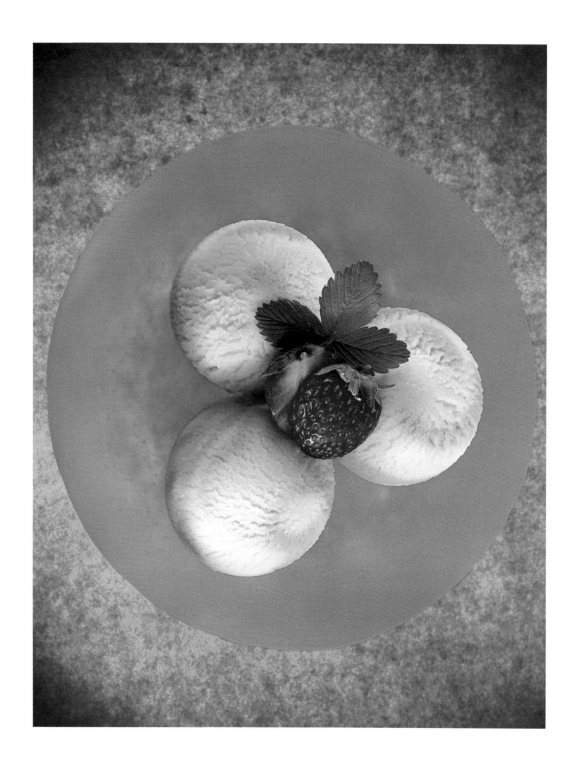

This picture is obviously a composite, with a number of different images shot separately and then combined on the computer. 'It was quite a problematic shot,' says Patrice de Villiers, 'because what they wanted was a Gordon's Gin swivel stick, lots of action in terms of bubbles and ice, a bit of lime – and they needed it to fill a certain section of a long, thin advertisement. It was a specific, detailed brief. They came to me with a layout and said, "How can we do this?" It was essentially a technical exercise – my role was to come up with ways of creating it.'

'The first problem was that the scale of the layout didn't work realistically. I had to think about the size of all the elements in relation to each other. In shots of these kind there's always one thing you can't change, and here it's the size of the segment of lime. So, I had a swivel stick modelled to the right size and asked a stylist to provide a range of glasses of different sizes. We chose a long whisky tumbler and started by putting a lot of Perspex ice cubes in it. I then had to position the swivel stick as required by the layout. I superglued it to the glass to stop it moving, and used a trace on the back of the camera to record the position. Then I positioned the lime in its specified place and held my breath as I poured in the tonic water. I took around 20 sheets of film, so the client had plenty of shots to choose from.'

'The main lighting is coming from underneath. The set is on top of a glass sheet which is resting on two trestle tables. 20cm beneath the glass there is a Perspex diffusion screen, and the light is lying flat on the floor. A second light coming from behind creates the green background – a fish fryer covered with green lighting gels fired through Perspex.'

'The bubbles are glass bubbles held in place by bits of wire, which I shot in water, to get the correct kind of refraction. When they were added to the main image to create the final shot, they were distorted further to make them look realistic.'

ⓐ Patrice de Villiers
ⓒ Gordon's Gin via agency, UK
ⓟ Advertisement
ⓕ 5 x 4 inch
ⓛ 210mm
ⓕ Fujichrome Velvia
ⓣ Various – multiple-exposure
ⓛ Electronic flash

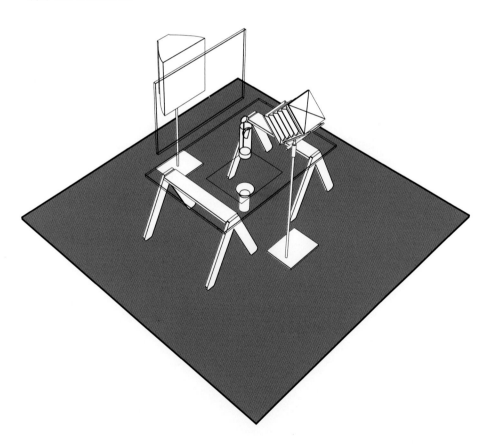

plan view

gordon's gin

Often images that appear to be computer-generated are actually composite photographs.

on fizzing

'Schweppes tonic water is the best – it's a lot fizzier than all the others. However, none of them stay fizzing for long, and one of the things I do is use a syringe to add bicarbonate of soda, which makes it re-fizz. You can do this two or three times before you need to siphon off the tonic water and go for it again.'

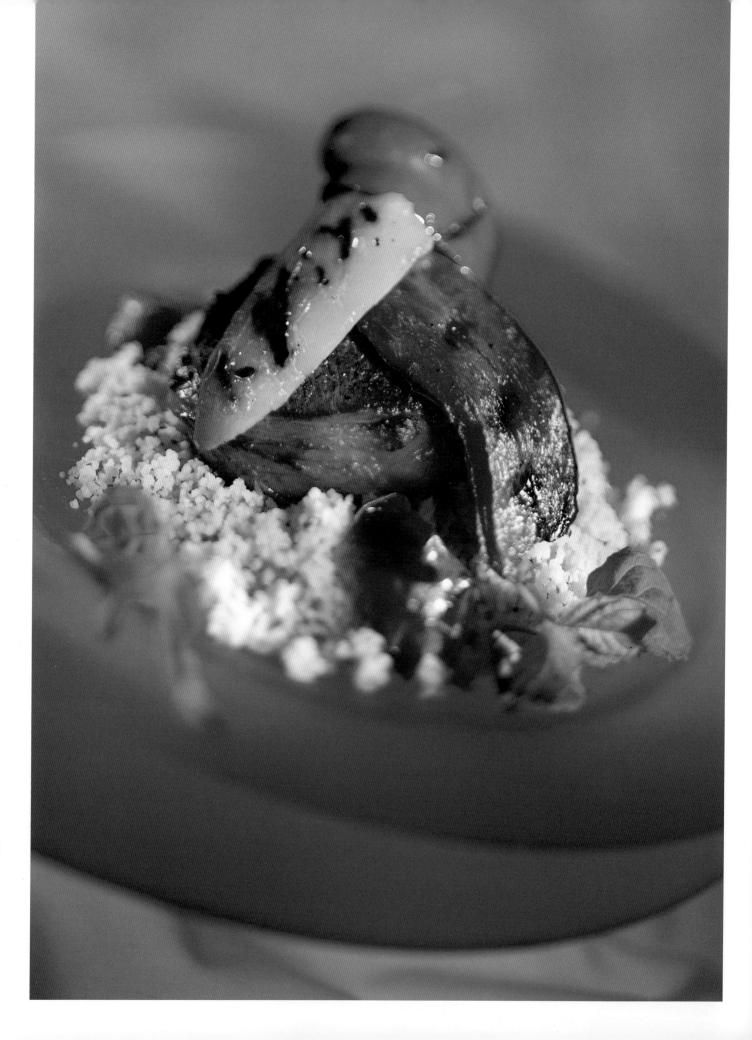

The blues in this picture have a wonderful glowing quality, and that's largely because they're lit from underneath, with a tungsten head fired through a sheet of white opal glass covered with silk and two frosted blue plates. To strengthen the blue colouration, a blue gel was fitted over the head, and barn doors fitted to control the spread.

Lighting the subject normally, without a gel, makes the beef and peppers stand out strongly from the background. 'Most of the time I work with just one main light,' says Kuypers, 'in this image I just used the tungsten head to the right of the camera. For a softer result, though, I bounced the light off a sheet of white polystyrene measuring around 45cm square. I then normally use reflectors and mirrors to fill in shadows and add highlights. Sometimes I stick mirrors onto the polystyrene, and that's what I did here.'

- Neville Kuypers
- Food stylist
- Publicity material
- 5 x 4 inch
- 250mm
- Kodak Ektachrome 64T (tungsten)
- f/5.6 at 1 second
- Tungsten

plan view

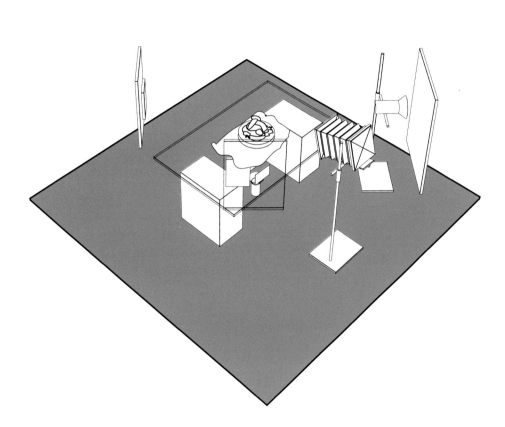

beef and peppers

Lighting semi-transparent materials from underneath gives an image a wonderfully luminous quality.

It's not unusual for still-life and food photographers to place objects in front of the light to throw interesting shadows onto it. Plants and foliage are popular and readily available choices, but many other things are also employed in studios around the world – though in a rather hit and miss, ad hoc fashion. However, it is possible to use this technique in a more controllable and creative way – and Dutch photographer Joost Berndes is one to do so as the need arises.

Berndes works by placing what he calls a 'koekoeloerea' (pronounced 'cuckoolurie') between the light and the subject. This is an open wooden frame measuring about 50 x 70cm across, over which he tightly secures a sheet of dark material that is similar to netting used by the Army. He then cuts holes in the areas where he wants to let the light through and leaves the material intact where he wants shadows. As with any screen, the effect depends upon how close you put it to the light or the subject.

For this image, Berndes placed the main light, a tungsten head, at the top right, with the koekoeloerea in front of it. An orange gel adds a hint of warmth to the subject. Providing a general fill is an overhead light, below which there is a second screen – this time covered with diffusion material – which works like a softbox. A gold reflector at the bottom left provides further fill-in. 'The effect is as if you were sitting under a tree with the sun sparkling through and producing a wonderful mood,' says Berndes.

Ⓐ	Joost Berndes
Ⓒ	Frico Dairy Food, The Netherlands
Ⓓ	Brochure
Ⓔ	5 x 4 inch
Ⓕ	150mm
Ⓖ	Digital capture
Ⓗ	Not known
Ⓘ	Tungsten

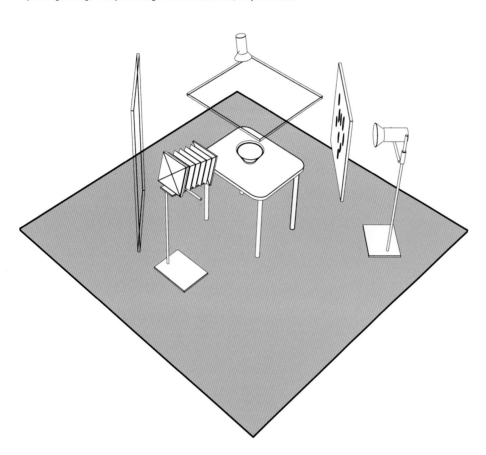

plan view

creating subtle shadows

Using special dark screens to cast shadows over your subjects is a sophisticated lighting technique.

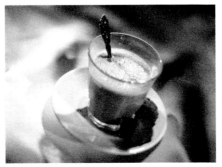

This picture was taken to illustrate an article on the history of the sandwich, and was, incidentally, one of the images which resulted in Patrice de Villiers winning the Sandwich Photographer of the Year title for two years running. Reading the article is essential in situations like this, and de Villiers will often ring up the writer and badger them to let her have sight of the copy, so she knows exactly what to illustrate. In this case she brought in stylist Janice Murphitt to make up the many different kinds of sandwich. The original sandwich is at the bottom – thin slices of beef in thin white bread devised by the Earl of Sandwich. Each sandwich then piled on is more modern and exotic than the last.

'This was a real heart-in-the-mouth shot,' says de Villiers. 'It took three hours to make the sandwiches, and we had five minutes to shoot before it all collapsed – and that was with all kinds of things going on behind the set. There were satay sticks holding things in place, helping hands with crocodile clips, superglue – and the sandwiches were starting to go off!'

The lighting was the easy bit – with a softbox on the left fired through a diffusing screen, and white card on the right. De Villiers wanted the background to be neutral but have a 'foody' feel – so she put some brown gels over a softbox and directed it through a trace screen behind the sandwiches.

👤 Patrice de Villiers
🌐 Observer Life magazine, UK
◉ Editorial
📷 5 x 4 inch
🔘 210mm
▶ Fujichrome Velvia
⏱ f/45 at 1/125sec
💡 Electronic flash

plan view

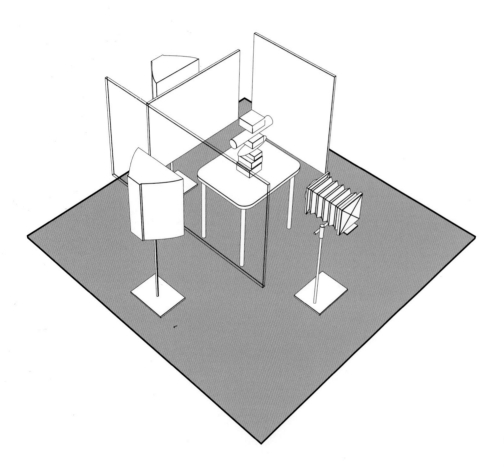

on backgrounds

'I usually only have a couple of things in the picture, and the background is an integral part of it – so it should never take over. I use mainly flat, non-specific backgrounds. I have a personal dislike of mottled backgrounds – most of the time they detract from looking at the subject.'

on stacking

'I like some kind of tension in a picture. Putting things on a flat surface doesn't have the same dynamic. Stacking is a good way of combining things. There's a feeling of gravity – and I'm constantly trying to find beauty through a balancing act.'

stacked sandwiches

Stacking is one sinple way of bringing disparate elements together.

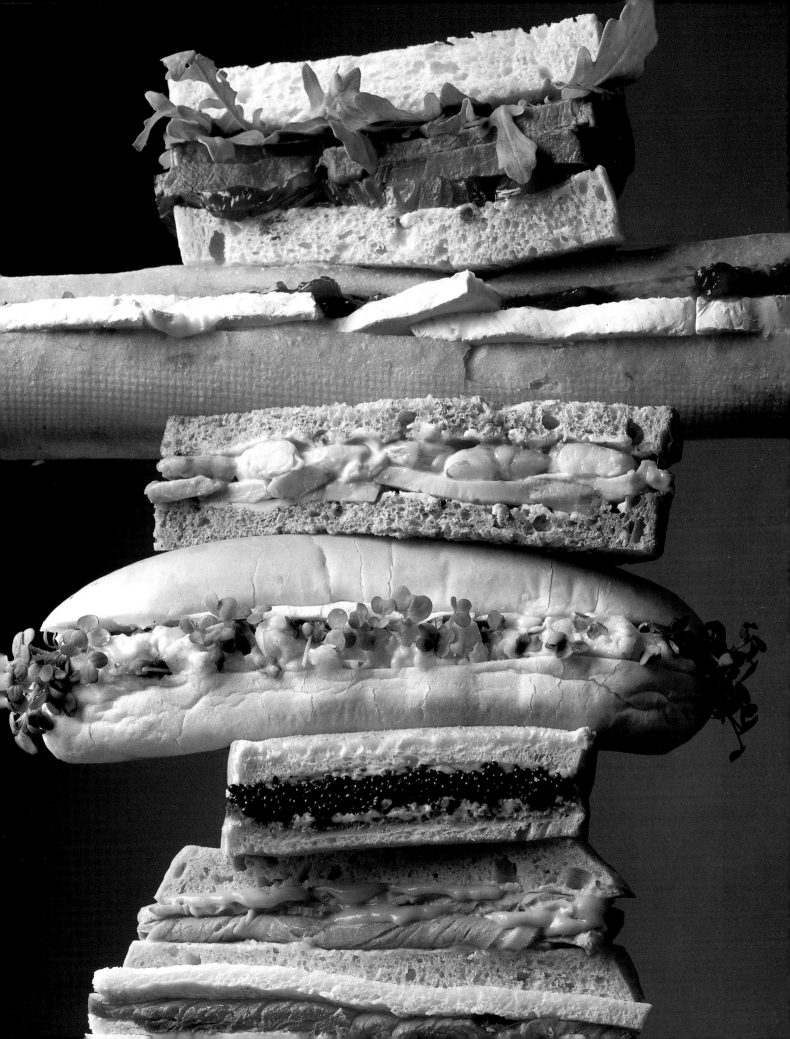

The idea behind the feature that this picture illustrated was an intriguing one: what menu would you choose for an unrepentant alcoholic? The answer which the writer had come up with was melon balls in vodka to start with, duck with blueberry sauce and Amaretto as a main course, and profiteroles and a liqueur to finish. The challenge for photographer Patrice de Villiers was how to say in a picture that all the recipes have alcohol in them.

'Using the appropriate glasses and the raw ingredients with a little bit of liquid was the obvious solution,' de Villiers says, 'but what do I do with the duck? Then it occurred to me that the top of the picture wasn't doing anything, and I decided to hang the duck there. Having a precisely balanced relationship between all of the elements is very important to me, and I positioned the lovely little curve on the duck's tail so it was just right in relation to the flick of cream on the profiterole.'

To give a clean white background a single head was fired through a sheet of Perspex placed in between the subject and the light; the light was carefully masked off just out of frame to avoid flare. The subjects themselves were lit with a softbox placed to the left of the camera.

 Patrice de Villiers
 GQ magazine, UK
Editorial
5 x 4 inch
210mm
 Fujichrome Velvia
 f/32 at 1/125sec
 Electronic flash

plan view

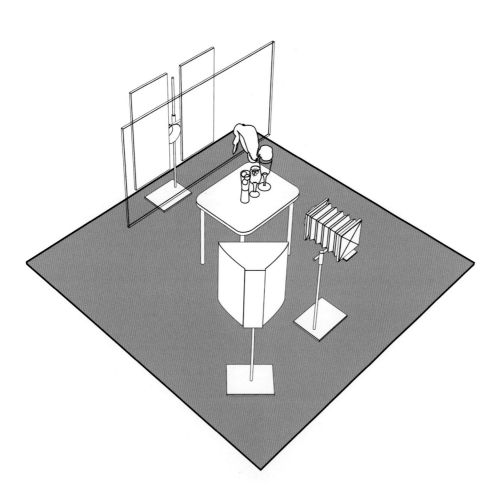

three glasses and a duck

Imaginative compositions retain the viewer's interest.

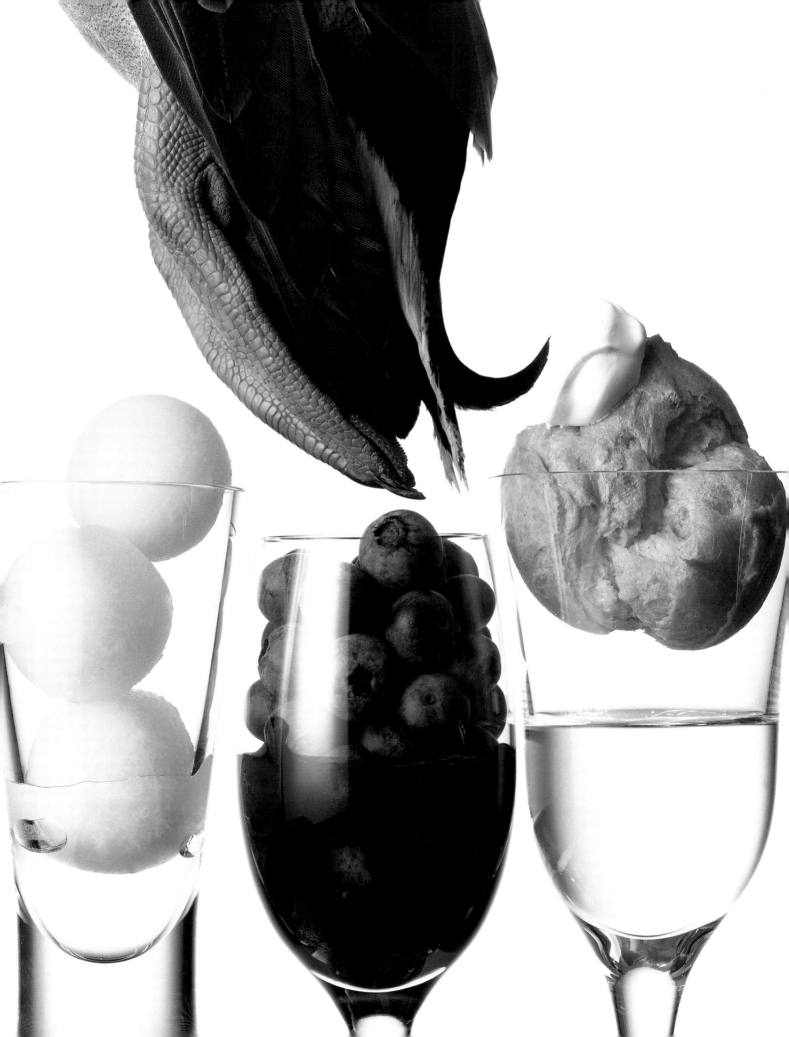

sophisticated set-ups

Specialist food photographer Neville Kuypers uses tungsten lighting for most of his work – but rarely lights the subject directly, preferring to bounce the light off mirrors, which he finds gives him a lot more control. This technique was employed for this colourful and luminous shot.

In order to show the marmalade effectively it needed to be backlit. But rather than put a light behind – which could have been difficult to hide – a mirror was cut to size, positioned a few centimetres back from the jar, and then lit with a tungsten spotlight from the left-hand side. Sheets of black card were used to prevent light spilling onto the subject or the background. Using a Hi-Glide system, a weaker second light was placed over the top of the jar and fitted with a blue gel to give the contrasting colouration on the spoon; without this, the shot could easily have looked a bit flat.

A third light was used for the background, which, surprisingly, was plain. The dappled effect was created by placing some bubble wrap packaging in front of the spotlight, along with a red gel.

Neville Kuypers
Candis magazine, UK
Editorial
5 x 4 inch
210mm
Kodak Ektachrome 64T (tungsten)
f/16 at 4 seconds
Tungsten

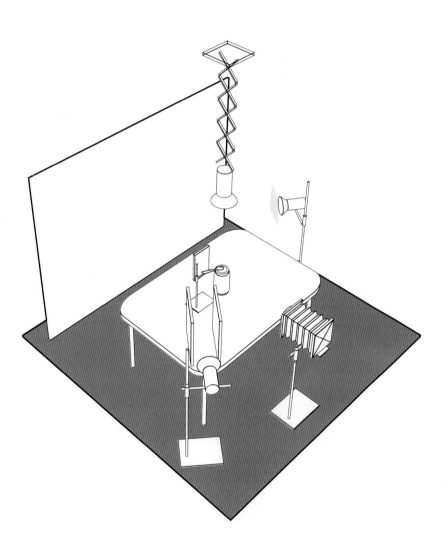

plan view

why tungsten?

'I like to be able to see exactly what I'm doing with the lighting,' says Kuypers. 'You're often working in confined circumstances with a plate-sized subject – sometimes as small as a single pea – and the difference between the output from the modelling light and the tube of an electronic flash head can be significant.'

The fact that tungsten lights produce a lot more heat than electronic flash is not a problem because of the way in which subjects are lit indirectly.

backlit marmalade

Indirect lighting with tungsten spotlights creates a luminous and colourful image of preserve.

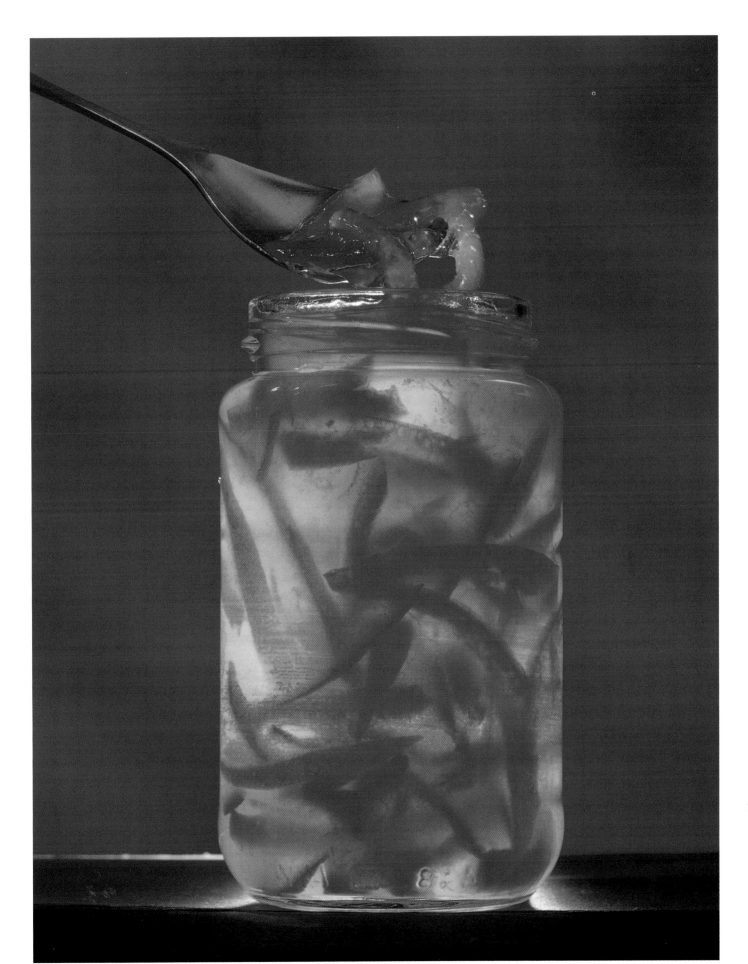

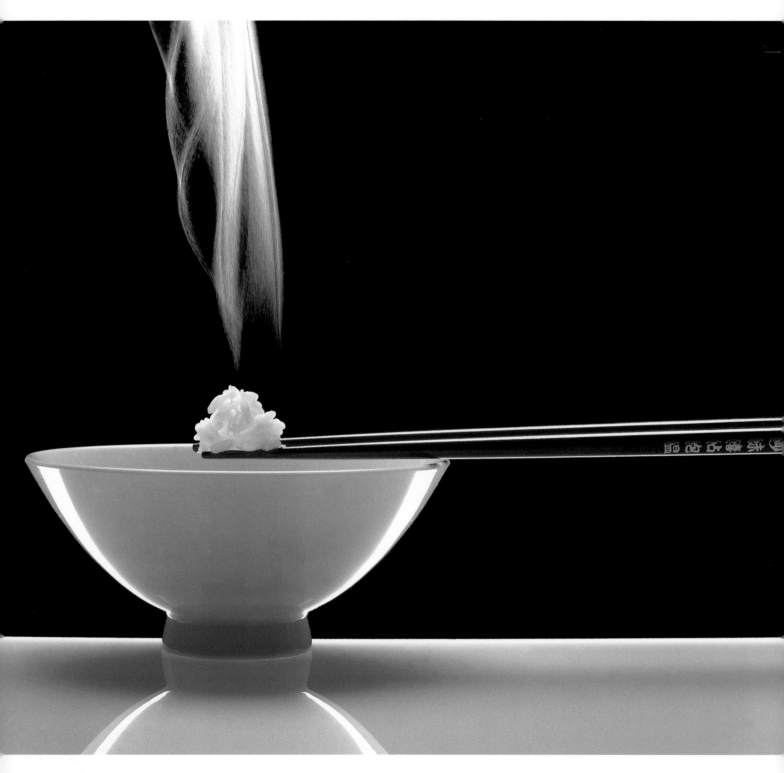

steaming bowl

A clever double exposure using black velvet creates a steamy image.

This image was part of a series taken for a book on cooking. The book's overall theme was that there was some kind of cooking action – so the steam is the crucial element here.

The picture was actually a double exposure, performed in-camera. One shot is of the bowl, the other of the steam. The first step was to mark the position of the subject's two parts onto the ground-glass screen of the 5 x 4 inch camera that was used. The steam was provided by a kettle, just as it came off the boil. In order that only the steam was caught on film, the bottom half of the frame was masked off, with black velvet placed both in front of the kettle and behind the steam. The lighting for the steam came directly from behind, with the softbox positioned above the area seen by the lens. To give the shortest possible flash duration, the power of the flash head was turned down.

The bowl is on a sheet of Perspex covered with a blue gel. There is a 1m square softbox under the Perspex, pointing upwards. Half of it protrudes beyond the Perspex, so that part of the light is blue, illuminating what is actually a white bowl; and part of it is white, creating the rim-lighting down the edge of the bowl. The illumination on the rice and along the top of the chopsticks came from a long mirror clamped in position above the set which reflected back the light from the softbox underneath. The overall lighting of the set is provided by a softbox at the top right of the camera.

- Gerrit Buntrock
- Reader's Digest books, UK
- Editorial
- 5 x 4 inch
- 360mm
- Fujichrome Provia 100
- f/8 and f/22 at 1/400sec
- Electronic flash

plan view

This production still shows the first set-up.

plan view

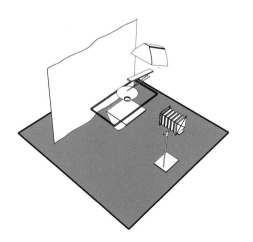

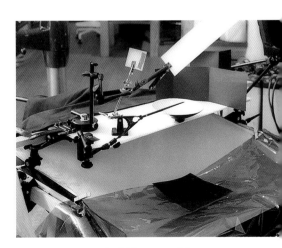

The second set-up – the fiddly nature of these sophisticated lighting sets is apparent from these production stills.

Silverware can be a nightmare to photograph, because it reflects the light in all directions. But what if you use that property to create something truly original? Here, Jay Corbett raised the knife, fork and spoon off the bottom of a deep plate by resting them across the rim; this allowed him to position his lights so they lit the underside and edge of the cutlery, reflecting it down onto the plate's base.

There are six lights around the set, all of them continuous tungsten fresnel heads. Four of them are placed at north, east, south and west, just above the level of the table-top, and fitted with barn doors that allow the direction and degree of light to be carefully controlled. Just a small slit was allowed here to produce a narrow band of light. Two further heads, fitted with snoots, are at the top left and bottom right, producing the highlight under the tines of the fork and the handle of the spoon. In addition, there's a 2.4 x 1.2m white card reflector above the set providing an overall fill, and this has a hole cut into it through which the lens looks down.

A 20 x 16 inch Cibachrome print was made from the transparency. This was coated with matte spray, allowing the photographer to work on the print with artist's pastels and coloured pencils to add a textural, painterly quality in the finished image.

- Jay Corbett
- Mikasa kitchenware, USA
- Brochure
- 5 x 4 inch
- 210mm
- Fujichrome Velvia
- f/22 at 10 seconds
- Tungsten

plan view

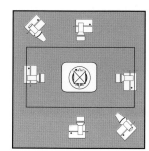

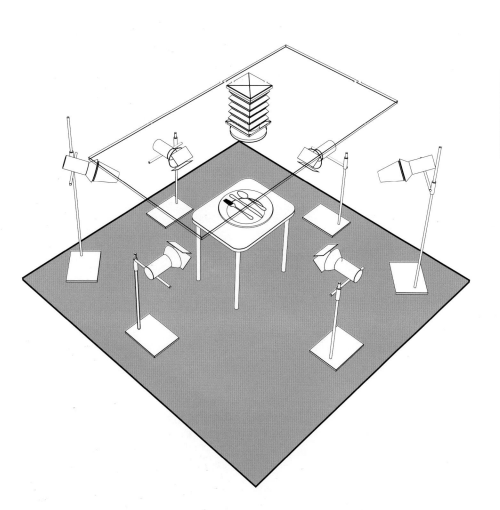

shimmering silverware

Raising the subject and lowering the lights allows illumination underneath.

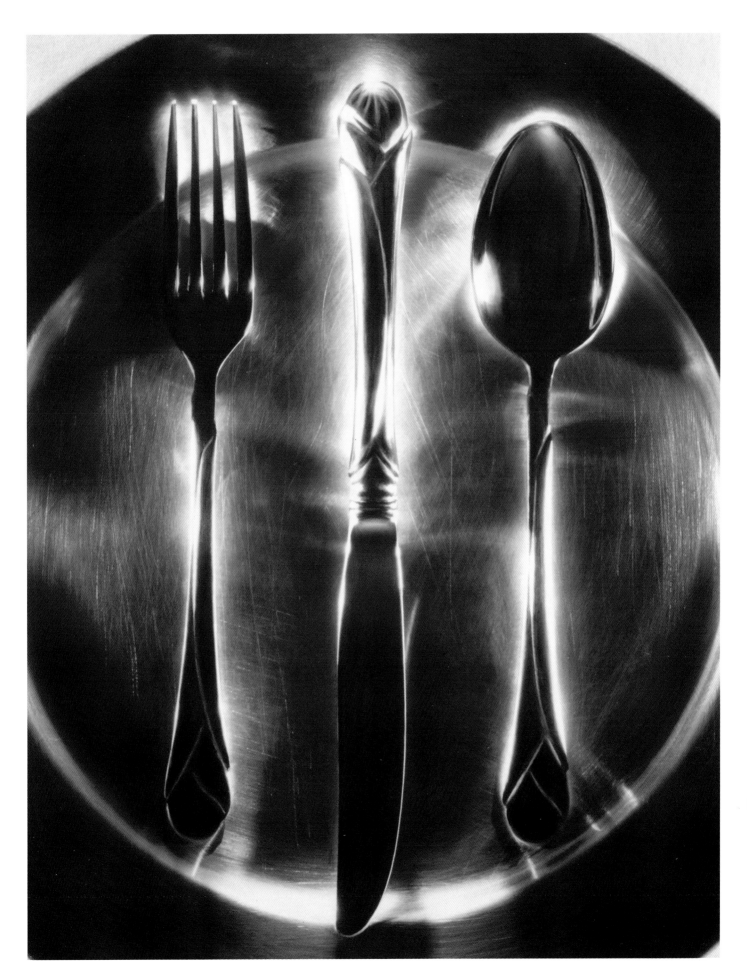

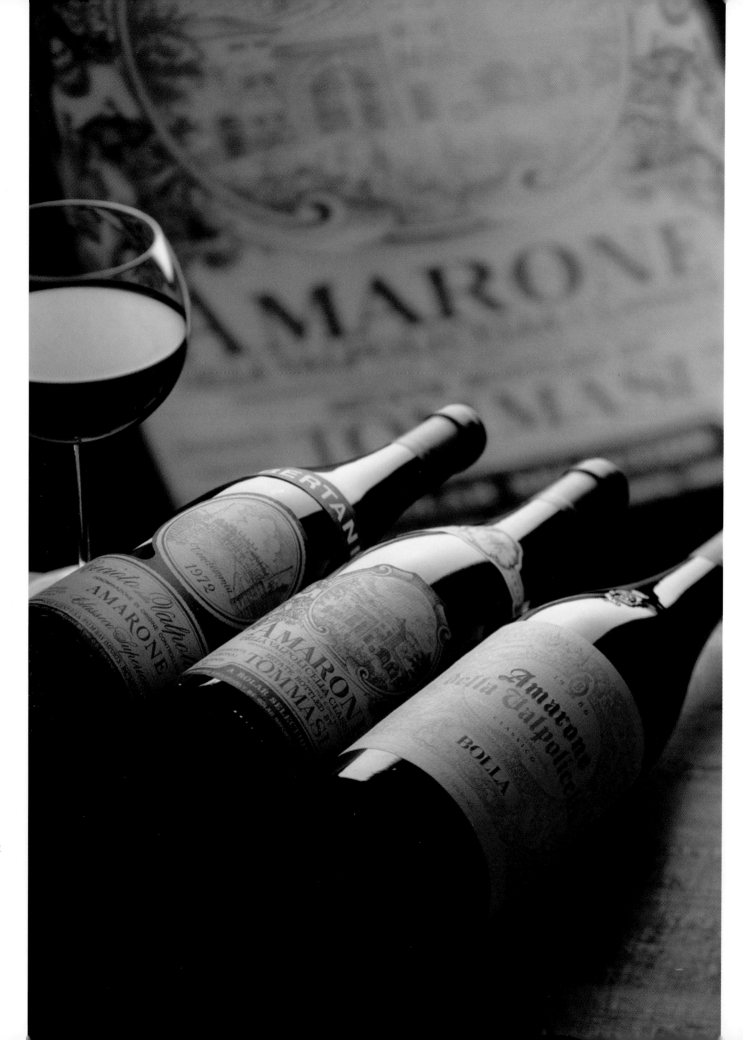

This picture was shot for the cover of a magazine, hence the space left at the top for a masthead. The image was subsequently used on a Visa credit card in the US.

The composition was a double exposure, with the bottles in the foreground lit by flash and the background projected during a time exposure. 'I started by photographing the label of one of the bottles using 35mm slide film,' says Becker. 'Once it had been processed, I arranged the set and the background so the name "Amarone" was in just the right position while leaving enough room at the top for the magazine logo.'

'The first shot was of the bottles, which were lit with a large softbox above and to the top left-hand side, so the shadows fell a little forward and to the right. I like having elongated highlights on many of my products – it helps give them shape and form – and here it also produces the highlight on the surface of the wine in the glass.' All that remained was to give the camera a slight forward tilt, so the front of the bottles would go soft and focus attention on the labels, and fire the shutter.

'The background on which the slide of the label was projected was a white wall 1m behind the set. An exposure of two minutes with the room darkened was required to get the right balance of exposure with the flash.'

Rick Becker
The Wine Enthusiast magazine, UK
Cover
10 x 8 inch
300mm
Kodak Ektachrome E100S
f/22 at 1/125sec and 2 minutes
Electronic flash and slide projection

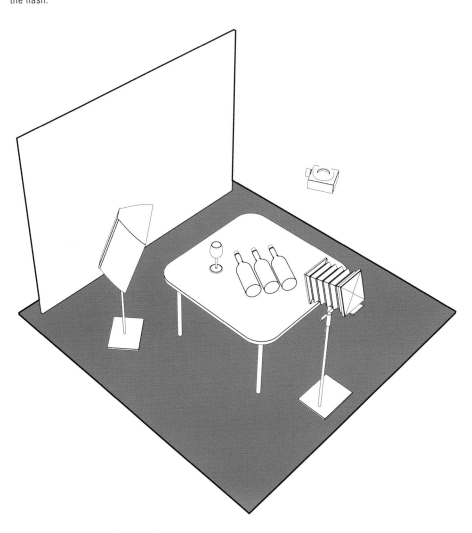

plan view

amarone bottles

Creating a double exposure using a slide projector produces a classy magazine cover.

The idea behind this shot is that of fruit pies on a kitchen table – with some already baked, cooling on a ledge in the background. So as to be able to control all of the elements, a set was built in the studio, with a fake wall and window some 2.4m behind. Despite the complexity of the arrangement, only four heads plus reflectors were required.

The main light is a projection spot on a boom arm at the top right pointing down to the bottom left. 'To give the burnt-out look I was after,' Becker comments, 'I had to fire the head a number of times. While I did so, I fitted a diffusion filter over the lens to give the picture a misty, ethereal feel.' A small softbox was placed to the right of the strawberries to provide both contrast-reducing fill and specular highlights, with a white reflector just out of shot to the front left to stop that area going too dark.

The light coming in through the 'window' is provided by a flash head in a 12.5cm reflector at an angle behind the set. The pies in front of it are illuminated by a low-powered softbox. 'I used a wide-angle lens because I wanted to get really close to the pies to make it look as if you could just reach out and grab them. That gave a nice perspective. I used a medium aperture of f/11 because I wanted the background to go soft.'

Rick Becker
Kitchen and Home magazine, UK
Editorial
10 x 8 inch
165mm
Kodak Ektachrome E100S
Timed exposure at f/11
Electronic flash

plan view

fruit pies

Despite a complex set, the lighting arrangement follows established principles.

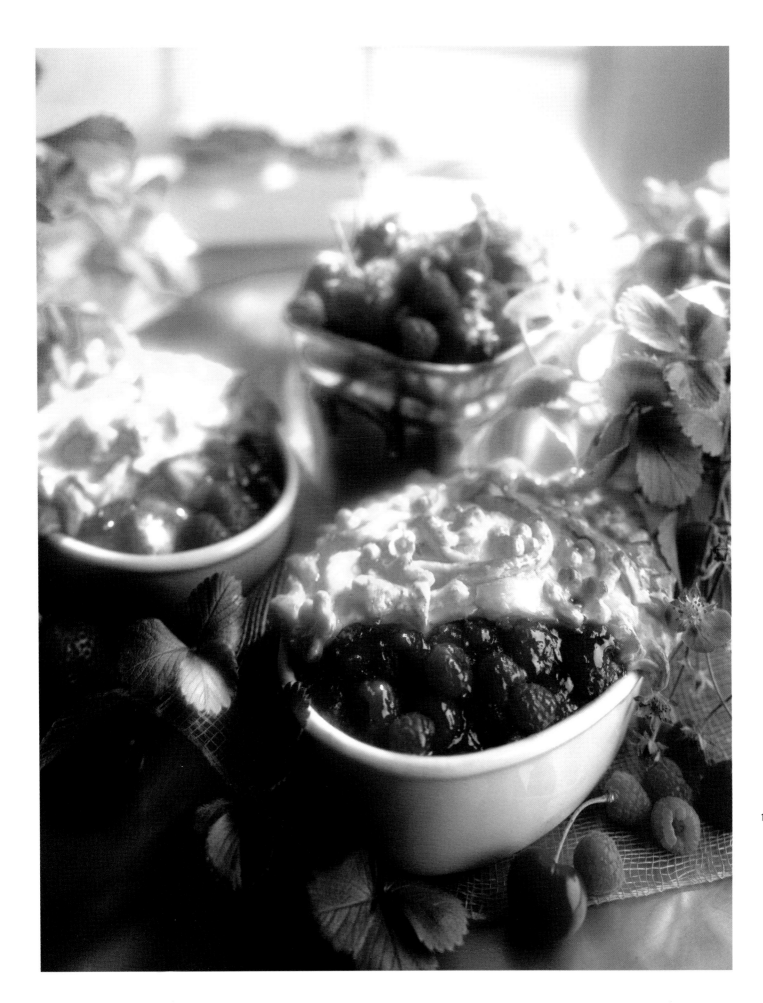

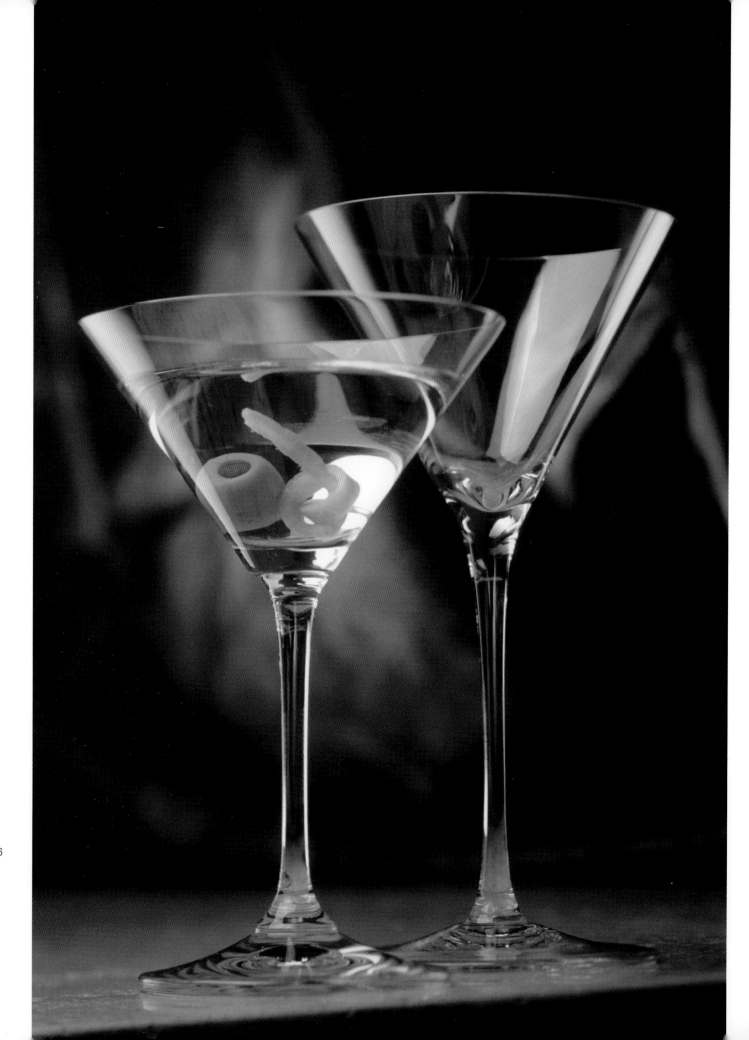

'When I shoot glassware,' says Becker, 'my aim is to produce edge-lighting – because it separates the subject nicely from the background. With Martini glasses that can be tricky, because the sides aren't upright.'

The way Becker dealt with the problem was to put the glasses close to the edge of the table and position both the camera and the lights below the level of the table-top – allowing the highlights to run all the way down the sides.

The lights placed to the left and right of the camera, either side of the table, are standard 61 x 100cm softboxes. These have been modified to make them into tall, skinny striplights by blacking out part of the surface area with pieces of black card. The background is a piece of exotically coloured tapestry lit with a flash head fitted with a honeycomb grid, placed over on the right-hand side.

Ⓧ Rick Becker
Ⓧ The Wine Enthusiast magazine, UK
Ⓧ Editorial
Ⓧ 5 x 4 inch
Ⓧ 150mm
Ⓧ Kodak Ektachrome E100S
Ⓧ f/16 at 1/125sec
Ⓧ Electronic flash

plan view

modifying a softbox

'Sometimes I'll use black card to change the effective size or shape of a softbox. I also put black tape across them to create a window effect. Often it's a simple cross, but if appropriate I'll make nine or 12 panels.'

martini glasses

Angled glasses require careful positioning of the lights and camera.

photographing biscuits

A single adaptable lighting set-up helps to theme a larger shoot.

Sometimes you're given a tight brief by the client or art director, with diagrams and sketches to show where everything needs to go; and other times you're allowed more creative freedom to come up with ideas yourself, as for this shot. Photographer Steve Payne was given lots of biscuits by leading food retailer Tesco and asked to show them off to their best for a Christmas catalogue. To maintain consistency between the many different images he had to produce, he developed a theme.

'I decided that in each shot we would have something sharp in the foreground, with the rest drifting off to softness,' he says, 'and because of the seasonal timing of the catalogue, I planned to have bright shimmery, silvery tones behind.'

Rather than indulge in an orgy of different lighting techniques, he began by establishing a basic three-head set-up that was then adapted as necessary for the particular shot in hand. Images were captured digitally, allowing him to confirm immediately that the shot was in the bag and move onto the next.

The three lights used were a large softbox as a fill over the top of the set to make sure everything was illuminated, and there were no heavy shadows; a spotlight coming in from the back and raking across the biscuits to reveal their texture; and a smaller softbox to one side, often the right, to give the shot a little more bite. The main difference between the various shots was the position and height of the spotlight. These basic elements were enhanced as necessary by a host of mirrors and reflectors.

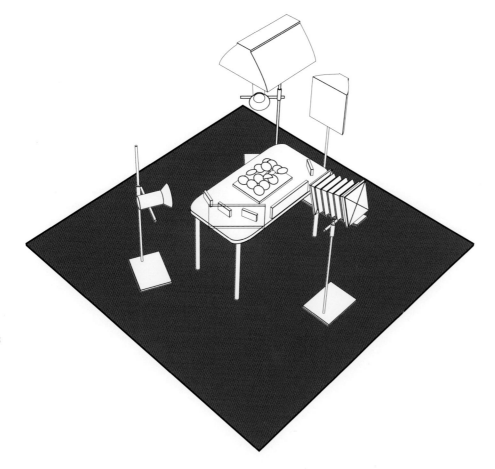

plan view

- Steve Payne
- Tesco supermarkets, UK
- Catalogue
- 5 x 4 inch
- 150mm
- Digital capture
- f/11 at 4 pass exposures
- Electronic flash

on working digitally

'There are a number of great things about working digitally,' describes Payne. 'You're not paying out for Polaroids. When the client's in you can show them a preview which is the right way up – unlike a large-format camera. You know the shot's in the bag before you move on; and it doesn't cost anything extra to try out the effect of small alterations, such as moving a cup or a spoon.'

chocolate biscuits

This picture features three types of chocolate biscuit – white, milk and dark. This represents a challenge for any photographer in terms of retaining detail in both, since lighting ratios have to be carefully controlled.

The first stage of the shot was for the stylist to cut a number of the biscuits in half and to fill in any holes with crumbs. They were then arranged attractively on the plate, and sundry sparkly objects positioned behind them.

To avoid the spotlight striking the top of the chocolate biscuits directly, it was lowered and moved slightly round to the right. Large reflectors were placed to the left and to the front to soften the light further, and there were a couple of mirrors also to the left side. A separate light was used to make the out-of-focus background glow.

129

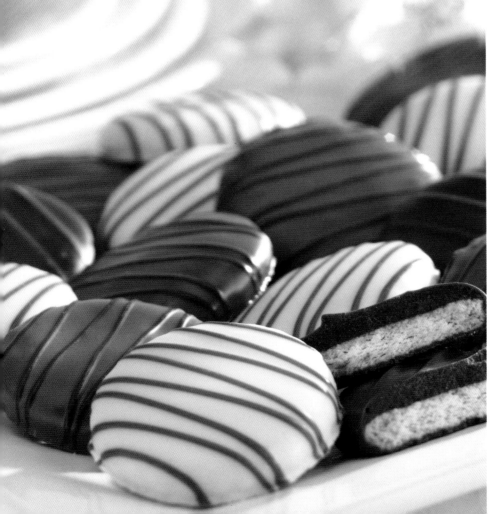

shortbreads

Because these shortbreads in the right-hand image are dull, matte biscuits, a more contrasty lighting approach was adopted. Moving the spotlight around to the right, raising it up and giving it extra power produces the highlight along the top edge, which is just 'blowing out' slightly. There's still the large softbox giving the overall fill from above, but the smaller softbox to the right is slightly farther back. Large reflectors at the front make sure the side the camera sees is fully illuminated.

The sparkly background elements are on this occasion produced by other chocolates wrapped in foil, with a separate light just catching them, and the out-of-focus cup giving an extra sense of depth.

colour temperature meter

'We use a colour temperature meter quite a lot. It's important to me to make sure all of the lights are balanced for the same Kelvin. Some can run a bit warmer and cooler, and it's possible to compensate for that with a gel over the front of the light. The last thing you want is a blue edge to a cup or plate – it ruins the whole shot.'

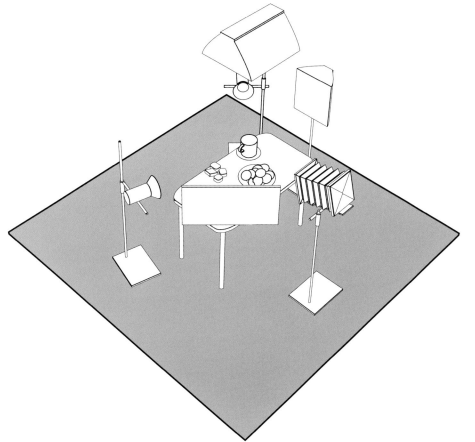

plan view

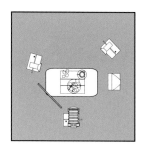

⊛ Steve Payne
◷ Tesco supermarkets, UK
◈ Catalogue
⊞ 5 x 4 inch
⊚ 150mm
▣ Digital capture
◷ f/11 at 4 pass exposures
◔ Electronic flash

131

This stylish image was originally created to go with a press release, but the client liked it so much it was subsequently also used as a full-page advertisement. The shot was an in-camera double-exposure, with the position of each of the component parts marked on the ground-glass screen of a 5 x 4 inch camera.

The first image was that of the bottle in the top-right corner, which was lit from behind by means of a tungsten fresnel spot fitted with a daylight-balancing gel. Sheets of black card were carefully placed to flag off the light and control the size and position of the shadow. The background was a sheet of hardboard painted white.

'I wanted to make use of the fact that the bottle was blue,' says O'Keefe, 'and this arrangement allowed me to produce a blue shadow. This was only possible because the bottle was square. Round bottles act like a lens and diffuse the light in an entirely different way.' A small shaving mirror was positioned to the left of the camera to bounce light back onto the bottle – otherwise it would have been in silhouette.

The second, larger image in the bottom left-hand corner was shot against a black velvet background. The bottle was placed on a little pedestal, and lit with two strip lights positioned vertically behind, pointing towards the camera. Sheets of white card covered with silver foil were placed either side of the camera lens to minimise flare and throw light back onto the front of the bottle.

 Peter O'Keefe
 First Drinks Brands, UK
 Press release/display
5 x 4 inch
210mm and 300mm
f/11 at 2 seconds
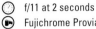 Fujichrome Provia 100
Electronic flash and tungsten

The lighting set-up for the image of the bottle in the top-right corner of the finished shot.

plan view

132

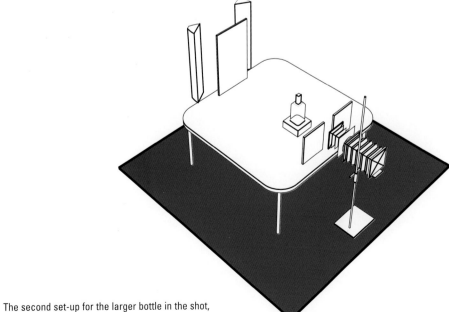

The second set-up for the larger bottle in the shot, taken on the second exposure.

plan view

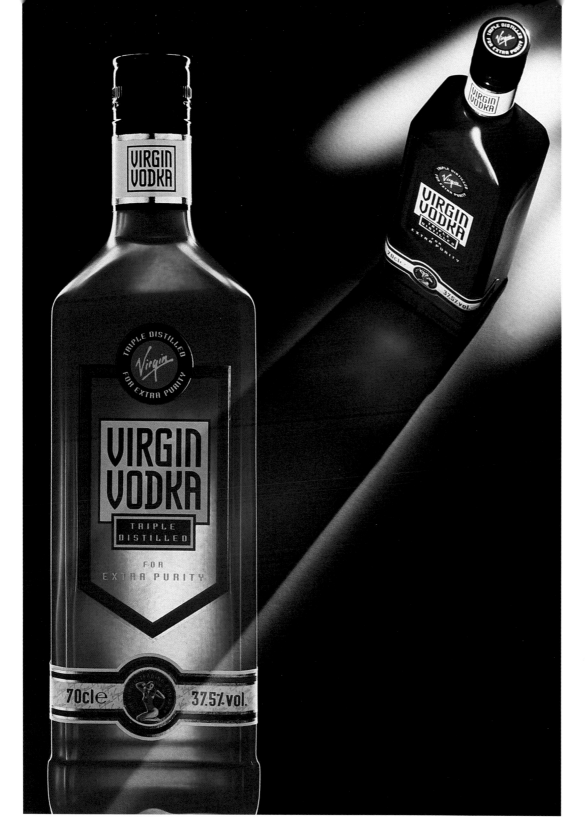

vodka bottle

Using creative lighting and combining two images in one produces a photograph with a lot of graphic impact.

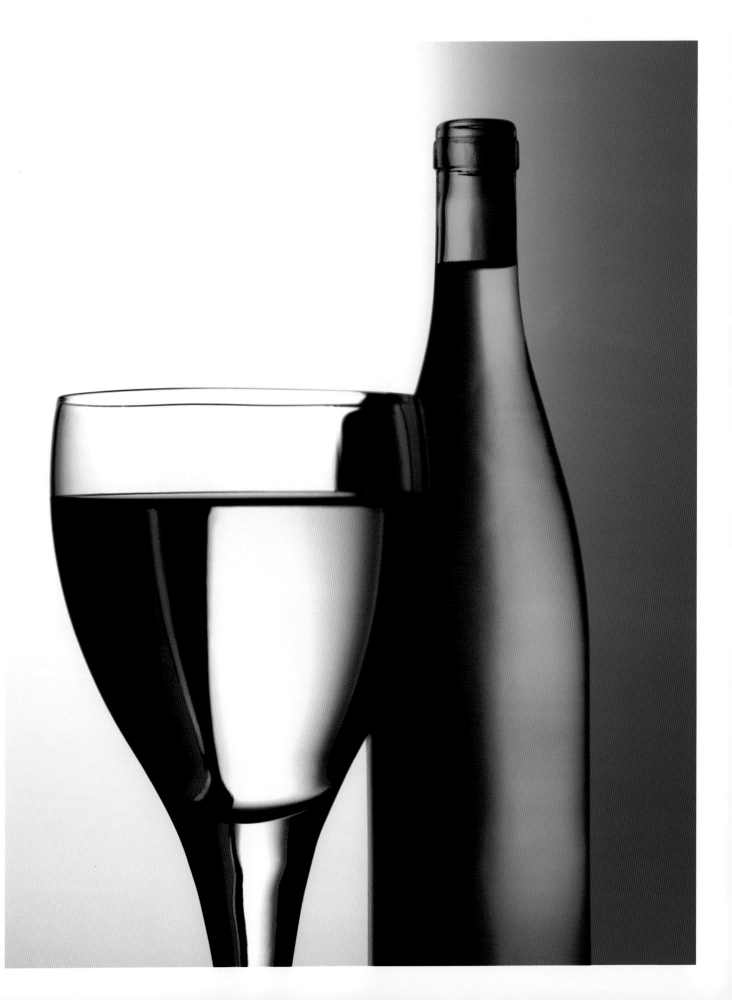

One of the best ways of putting a dark edge down a bottle or glass is to use black reflectors. Here, photographer Paul Webster built a tight frame of reflectors around the set, just out of view of the lens.

All the lighting comes from behind the glassware – from a continuous output HMI light fired through a screen to soften it. Taping a length of blue gel to the screen, which acted as the background, created the blue strip. By positioning the bottle and the glass carefully, the blue and green make a strip of colour in the glass, sandwiched between refractions of the black reflectors.

The only complication with this arrangement was that it was impossible to get sufficient depth-of-field to keep both the bottle and the glass in focus – but since Webster was shooting digitally it was no real difficulty. He simply photographed the bottle on its own, without the glass, then put the glass in and took another picture focusing on the glass. The image of the glass was then cut out digitally and dropped onto the image of the sharp bottle. The result is totally clean and graphic, allowing a broad range of uses.

🚶 Paul Webster
💬 Ceta film processing, UK
🎯 Advertisement
📷 5 x 4 inch
🔘 360mm
▶️ Digital capture
🕐 f/22 at 1/40sec
💡 Continuous HMI lighting

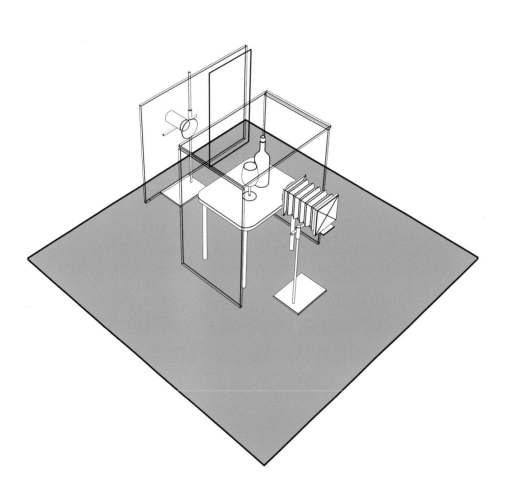

plan view

glass and bottle

135

Backlighting through a gel adds colour to a glass and bottle.

'This shot was done as a test shot for Mouton Cadet,' says photographer Jay Corbett. 'They were holding a photographic contest for images to be used in international advertising. My stuff was less traditional than most of the entries because it didn't actually show the product. Instead I was trying to capture the "idea" of wine.'

'The picture was taken on a standard plexiglass sweep table. A tungsten light was placed directly behind the glass of wine, which created the burnt-out circle behind the glass which also comes round the edge of the bottle. The long highlight on the bottle was created by placing a softbox to the right of the camera. Two sheets of black card were placed over the front to produce a narrow, controllable strip of light. There was more black card to the right of the glass and to the left of the bottle to darken them down a little.'

'Most of the distortion on the glass was created by having it out of focus and by the light burning through and "blowing out". However, I also placed a piece of polythene inside the bellows of the camera, which contact-printed the artistic pattern by randomly inhibiting light falling onto the film according to the pattern on the polythene.'

Jay Corbett
Personal project
Portfolio
5 x 4 inch
180mm
Fujichrome Provia 100
f/32 at 4 seconds
Tungsten

plan view

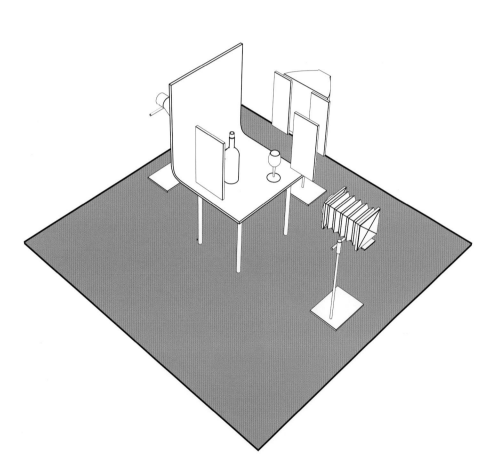

wine

Blast a light through the back of the set to produce 'blown-out' areas.

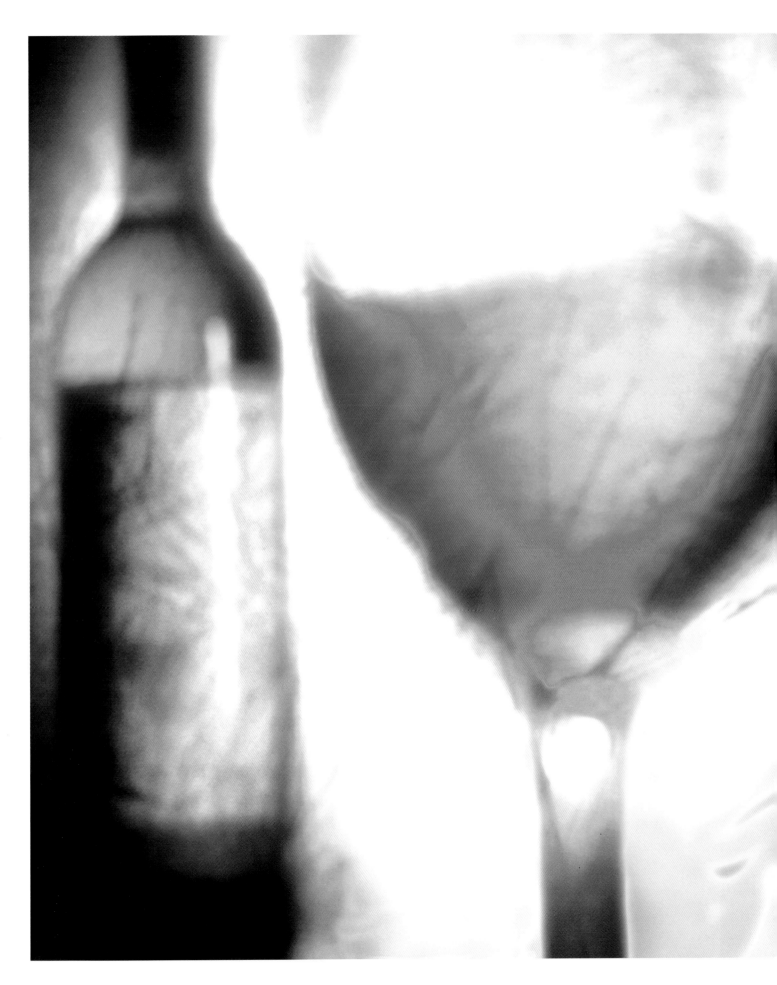

With millions of stock images already filling the bulging files at libraries around the world, you need to come up with something original and exciting to stand a chance of making a sale. With that in mind, Steve Allen decided to produce a series of pictures of various fruit and vegetables being dropped into water – using electronic flash to freeze the resulting splashes.

To be able to control the various elements, an aquarium was set up in the studio, with a white sheet 1.2m behind. Two flash heads with reflectors were directed at this to produce a clean, crisp background. The subjects themselves were illuminated by a softbox on each side of the camera, angled downwards to give the feeling the light was coming from above. The camera was placed just a little below the water level, because although a lot of the action is below the surface of the water, the splash is above it.

Naturally, since it was an action subject, and each execution would be different, Allen took a series of pictures – and chose the best ones for the library. 'I started by getting my assistant to drop the peppers in and watching what happened,' he says. 'Although it's over in an instant, it's not so fast you can't get a good idea of what's going on. Different shapes and different weights all hit the water differently. As a general rule, large, heavy things make a bigger splash and are less controllable. Then it's just a matter of testing with Polaroids, and when you're happy, firing away.'

(🚶) Steve Allen
(↻) Picture library
(◉) Stock image
(▦) 6 x 7cm
(◎) 110mm
(▶) Kodak E100SW
(◷) f/22 at 1/400sec
(◉) Electronic flash

plan view

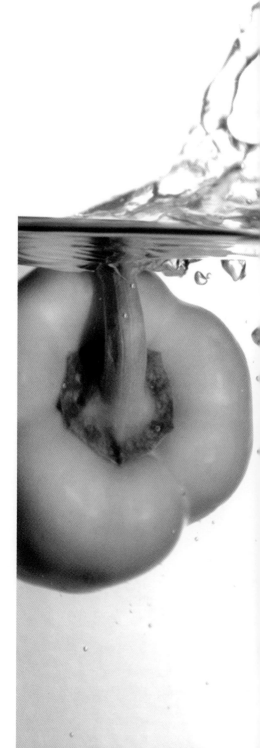

138

peppers in water

Crisp, clean lighting is ideal for creating original stock images.

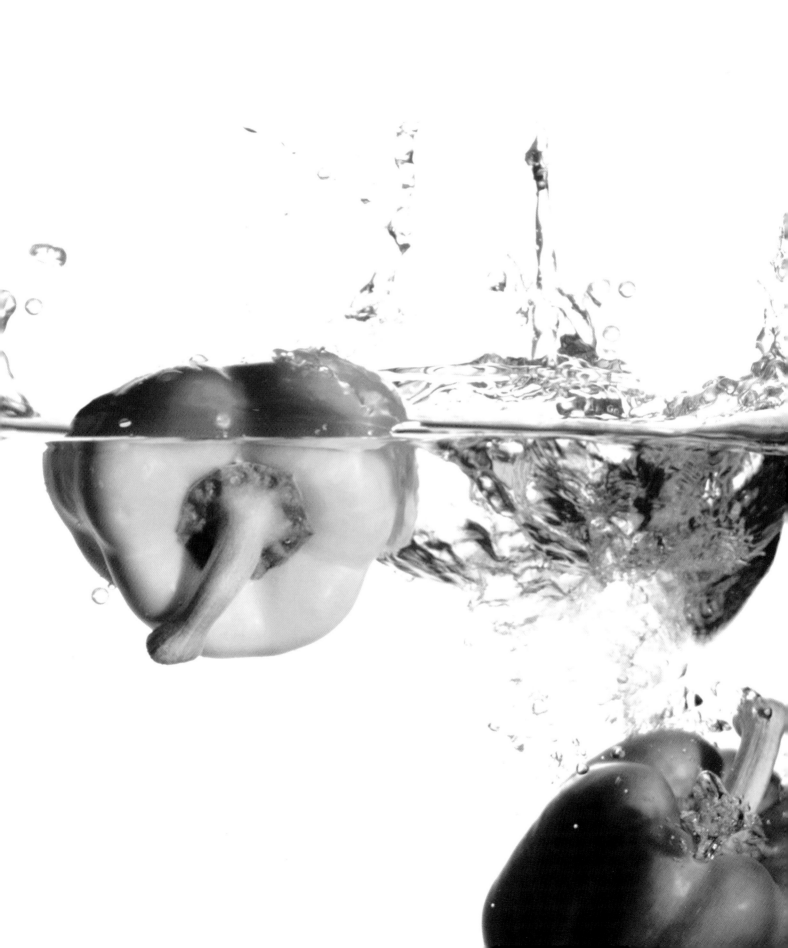

Looking to produce a test shot to pitch to a potential client, Steve Payne, working with a home economist, bought around 40 prawns, cooked them and then sorted through them for the one that was perfect in terms of colour, shape etc. The prawn was then fixed in place between the chopsticks, which had been painted and individually clamped, so they could be manipulated separately. The idea was to give the impression of the prawn being dipped, so the pastry basket was created to provide as much visual interest as possible.

The lighting, using three heads, was relatively simple. The main light was a spot at the back left, designed to shine through the prawn and rim-light it. Over the top was a large softbox giving an overall fill. A smaller softbox of lower power was coming in from the right. A white polystyrene board at the left and various mirrors at the front were carefully positioned to bounce light back in, giving the best possible lighting balance.

Steve Payne
Personal project
Portfolio
10 x 8 inch
240mm
Kodak Ektachrome E100VS
f/32 at 1/60sec
Electronic flash

plan view

prawns

Attention to detail produces a clean, elegant food shot.

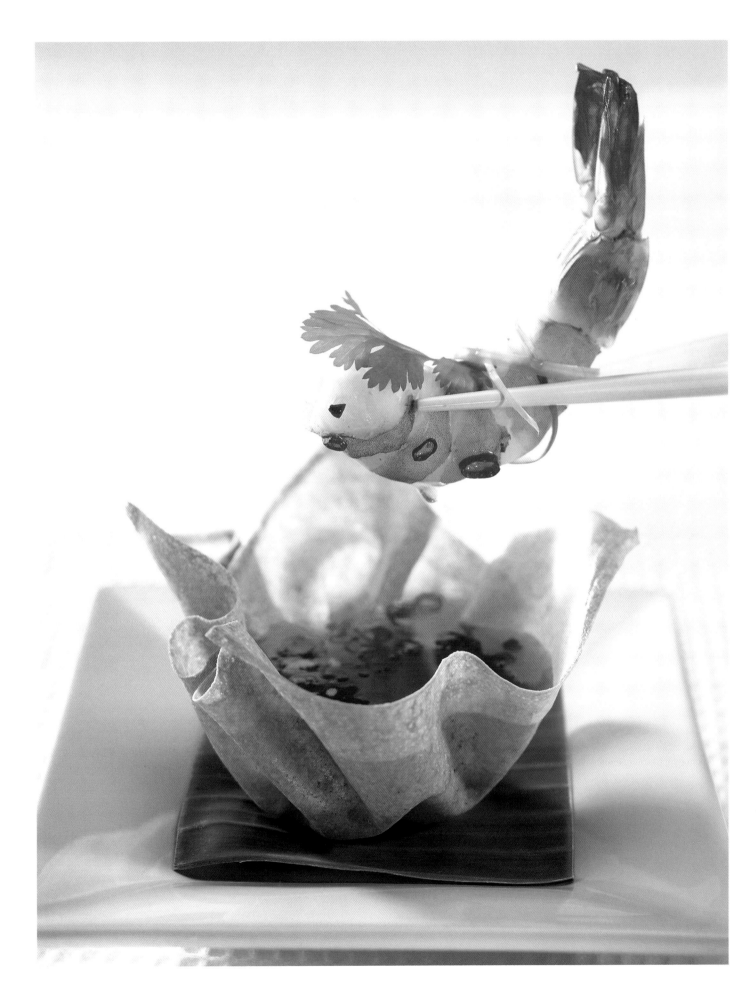

dynamic light-painting

Light-painting is a sophisticated approach to food photography that gives supreme control.

These pictures were all part of a set that Steve Allen took for stock use. 40 different fruits and vegetables were all photographed using the same techniques – light-painting, selective focus and the use of vivid colours.

Allen is an expert with the Hosemaster light-painting system, and he employs it to create lighting effects that simply could not be achieved by any other means. 'If you only use the light-painting system, and no ordinary lighting,' says Allen, 'you get a distinctive feel – because it's not natural lighting. You'd never see it like that in reality. A lot of the skill demanded by the Hosemaster system I use is in how you move the probe. If you move it parallel to the background, it will be evenly lit. If you move it in an arc over an area, that area will be brighter in the middle than at the extremities.'

'With this series I tried to light the various things in a way that would be interesting to the viewer – in order to make the most of what are relatively mundane subjects. Part of that was to have one thing in the foreground in sharp focus and then a group in the background out of focus. For most of the series I went in close with a wide-angle lens, which gives a wonderful sense of depth, even though the distances involved are actually very small. The wide-angle lens also gives a perspective that's alien to the view from the eye. To inject a dynamic feel I often tilt the camera to produce a diagonal composition – in fact, I rarely have it straight.'

'I like shots to have vivid colours, and here the lines have been created by putting a filter over the light-painting probe and building up the exposure. What I tend to do is shoot one Polaroid as a test, then I do three or four different executions, perhaps switching the coloured filters around or lighting specific areas more or less.'

These bananas have also been photographed at an angle, to accent their swooping curves. The yellow filter has been used, to intensify their colour.

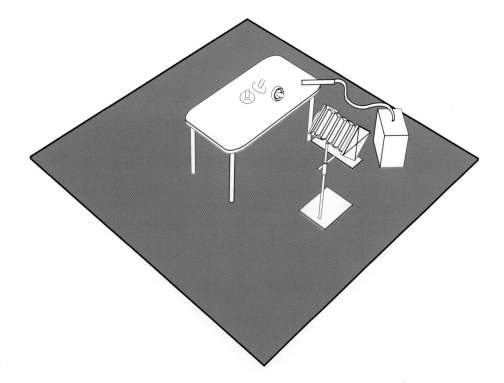

plan view

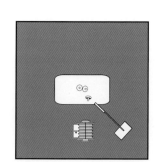

142

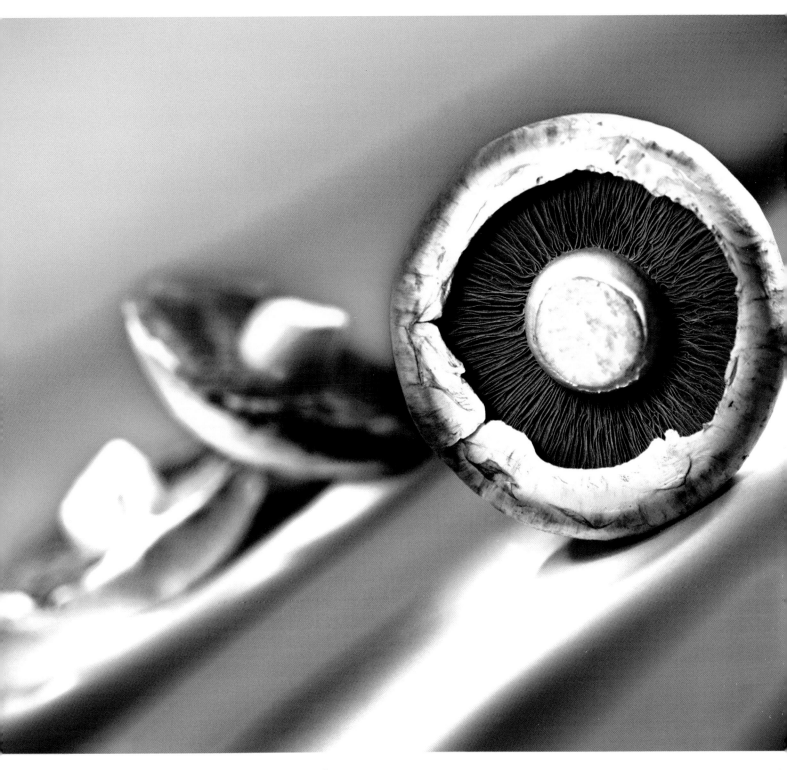

🚶	Steve Allen
📷	Picture library
💠	Stock image
🎞	5 x 4 inch
🔘	75mm
🎞	Kodak E100SW
⏱	f/8 timed
💡	Lightbrush

mushrooms

Placing the mushroom on its side made it easy for Allen to reveal the texture of the lines underneath using light-painting, while highlighting the right-hand edge gives the impression of light coming in from the side. By tilting the camera, a dynamic diagonal has been created that takes the eye from the left-hand corner up to the top right. The red, green and orange strips were produced by fitting various filters over the light-painting probe and making broad sweeps over what is actually a white background. Using an aperture of f/8 means the two mushrooms behind are well out of focus but still recognisable.

fennel

Going in close means the fennel completely dominates the image, although sufficient space has been left for the second root behind to be seen out of focus – giving the shot an excellent sense of depth. Also, it has been lit with orange, to help the foreground subject to stand out. Careful light-painting, with highlights around the base and in the centre, and rim-lighting from behind, gives the fennel a monolithic, sculptural appearance.

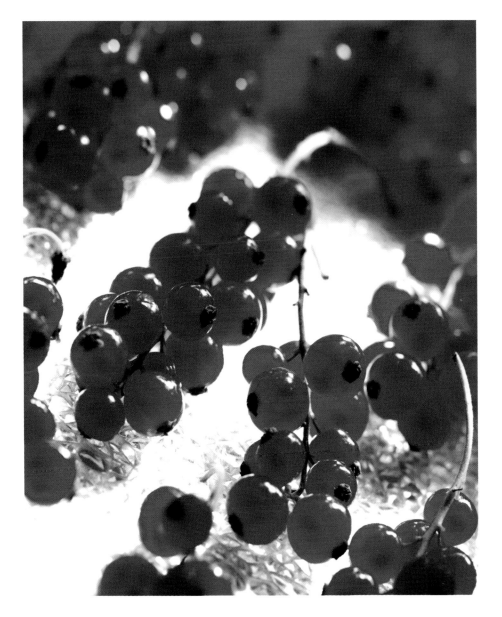

how the system works

As with many studio flash systems, the power for a light-painting system is provided by a pack which can be wheeled around to wherever you want it. But what's different is that the pack features a Xenon source, and instead of being connected via cables to flash heads which fire when triggered by the camera, there's a long fibre-optic hose down which the flash is channelled. At the end there is what is essentially a torch, which you can switch on and off at will – giving you a flash tube that can run continuously.

When light-painting you work in the dark, with the camera set to B. Switching the unit on simultaneously opens a secondary shutter that's fitted to the lens of the camera and emits light from the torch. By switching the unit on and off, and moving the head around, you literally paint the subject with light. The longer you keep it on one area, the lighter it will be in the finished image. A beeping noise usually counts off the seconds. Because you can't use an exposure meter, you need to start with a series of tests to ascertain what times and apertures to use. The light from the raw head is incredibly bright, but a range of tools is also available which allow you to control and shape it – as well as a button which switches on a soft filter that allows you to produce 'glow' effects selectively on parts of the image. Filters are also available to colour all or part of the subject.

redcurrants

One of the great advantages of using light-painting for food is the precise control it gives you. Because the probe is so tiny, it's possible to illuminate specific parts while leaving other areas dark. Small subjects like these redcurrants are especially tricky, and getting this kind of result with standard lighting would be impossible. But by moving it in and out of the spaces between the bunches, and increasing the exposure on the background to burn it out, a vibrant, punchy close-up has been created.

These three pictures were taken to decorate a famous supermarket in São Paulo, so it was important that photographer Cicero Viegas be consistent in his use of lighting. In each case he fired a flash head in a reflector through a sheet of Rosco Tough Frost diffusion material over the top, and slightly to the back of the set, to provide an overall and extremely soft fill, with other lights and reflectors placed around the outside.

In the case of the fish, there was a small softbox to the left of the camera and a standard head to the right. The warmth was added by means of a 1000W tungsten light at the top left, which also helped reveal the texture. 'The main difficulty was the composition,' says Viegas. 'Because all of the elements were perishable, we had to work very, very quickly.'

- ⊕ Cicero Viegas
- ⊗ Supermarket Pão de Açuzar, Brazil
- ⬡ Banner
- ⊛ 5 x 4 inch
- ⬤ 300mm
- ▣ Fujichrome Velvia
- ⊙ f/32 at 1/60sec
- ◯ Electronic flash and tungsten

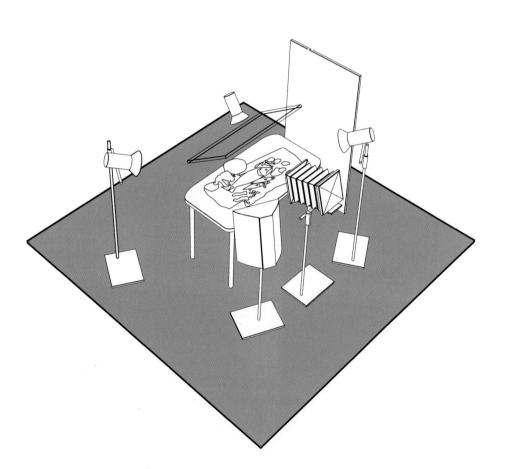

plan view

146

lighting for groups

The more elements there are in a photograph, the more complicated the composition and lighting becomes.

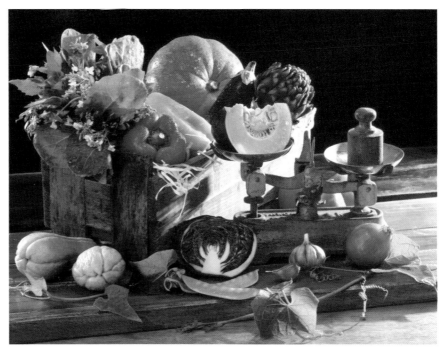

The brief was for 'a shot with sparkle', so one of the first things photographer Steve Payne did was to employ a stylist to track down some attractive glasses of different shapes and designs. These were then arranged on a glass table-top, underneath which were placed pieces of reflective, silvery material that were lit brightly by two spotlights, placed at the right and at top left, with reflectors opposite them to bounce light back in.

The main light was positioned under the Perspex at the bottom right and angled up to transilluminate the liquids in the glasses. The output of a large softbox over the top and a smaller one to the side were balanced to give the required lighting ratios. Carefully positioned mirrors provided the final touches.

- Steve Payne
- Tesco supermarkets, UK
- Catalogue
- 5 x 4 inch
- 150mm
- Digital capture
- f/11 at not known
- Electronic flash

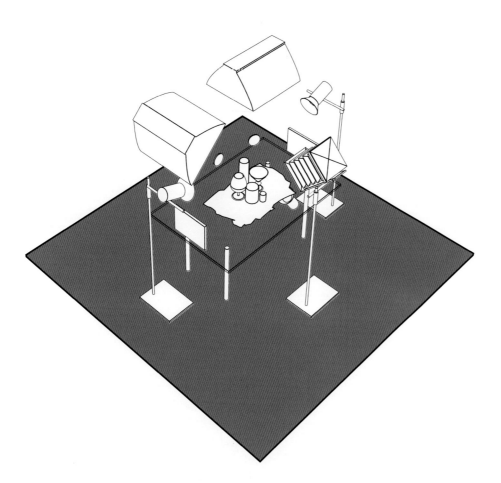

plan view

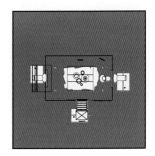

on mirrors

'We've got loads of mirrors,' Payne comments, 'which we use to give fill-in and highlights wherever necessary. Some are ordinary shaving mirrors, which are extremely versatile – one side is convex, so it gives a more focused light – or they come on a stand that can be easily adjusted. We also have a stash of pieces of broken mirror of different sizes and shapes, which we blu-tac to things like cans to place them just where we want them.'

drinks and glasses

148

Lighting from underneath brings out the colour of liquids in glasses.

'It's very easy when you've been working for some time to keep using the same techniques,' says photographer Pelle Bergström. 'But if you do it gets boring and you end up being a bad photographer, so I try to do things differently almost every time. With this carved watermelon I had the idea of creating a halo of light around it, and to achieve that effect I surrounded it with a cube using white reflector boards around 1m in size.'

The melon itself is suspended in the centre of the cube by means of wire, so it's surrounded on all four sides by the boards. Underneath there's a plexiglass table, and one corner is partly open to allow the camera an unobstructed view.

The melon is lit indirectly with lights that come in from behind. A head on the left is fired onto the right inner wall while a head on the right is reflected from the left inner wall. 'Because the light is bouncing around inside this little reflector box,' explains Bergström, 'you don't need a front light.' The resulting negative was scanned in and then manipulated a little, with the black background added and the wire removed.

- Pelle Bergström
- Wallpaper* magazine, UK
- Editorial
- 5 x 4 inch
- 210mm
- Kodak 100 Print
- f/32 at 1/60sec
- Electronic flash

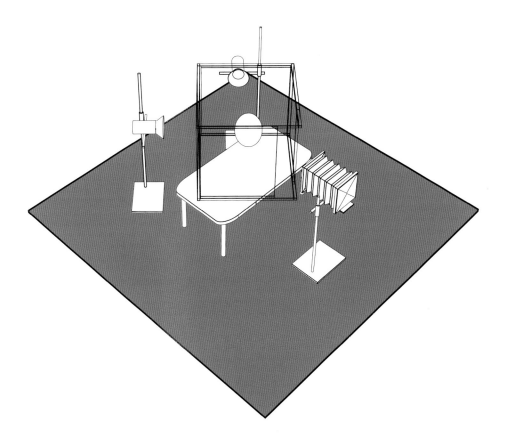

plan view

carved watermelon

The jewel-like quality of this carved melon was created by innovative and ingenious lighting.

directory

photographer	Steve Allen
address	Lindon House
	The Green
	Slingsby
	York YO62 4AA
	England
telephone	+44 (0)1653 628687
fax	+44 (0)1653 628687
email	mail@steveallenphoto.com
website	www.steveallenphoto.com

Steve Allen is an industrial, commercial and stock photographer with 24 years experience as a professional. Stock now accounts for 65 per cent of his turnover. He is a Fellow of the British Institute of Professional Photography and of the Master Photographers Association. Steve shoots a mixture of 5 x 4 inch and medium-format, almost all on transparency film. He is an expert at Hosemaster light-painting.

photographer	Joachim Baldauf
agent's address	Daniela Wagner Photographers
	Preysingstrasse 22
	81667 Munchen
	Germany
telephone	+49 (89) 489 0220
fax	+49 (89) 489 02217
email	kristina@danielawagner.de
website	www.danielawagner.de

Baldauf studied textile design in the German Alps before working as a graphic designer for the advertising industry; he came to photography through cover design. He loves the photography of the post-war years when very expressive results were achieved using the simplest means. In his work Baldauf aims to combine elegance, naturalism and humour. He enjoys the family atmosphere that comes from working within a tight-knit team, and he views his models as muses rather than empty, emotionless shells.

photographer	Rick Becker
address	500 Broadway
	5th Floor
	New York
	NY 10012
	USA
telephone	+1 (212) 925 3974
fax	+1 (212) 925 5073
email	rickbecker@earthlink.net
website	www.rickbeckerstudios.com

'At this time I'm happy to say I'm the president of Becker Studios on Broadway, engaged primarily in very successful advertising photography with a long and impressive list of clients, any of whom can vouch for the fact that I bring energy, enthusiasm and a high calibre of professionalism to a shooting assignment. While I'm a perfectionist in terms of what I bring to a client, I'm also adaptable and easy to work with.' Much of this comes out of Rick's genuine love for the craft of photography, a love of people and travel. In addition to his studio work and exhibition effort, he gives slide shows and seminars. His current projects deal with multiple imaging, exploring 'movement' with still photography, and exploring alternative processing and printing techniques. 'My philosophy concerning advertising photography is simple enough – to constantly make the most interesting and exciting photographs and at the same time promote the product of the client in the best possible light.'

photographer	Pelle Bergström
agent's address	Johanna Strinnvik
	SKARP AGENT AB
	Hökensgata 8
	S–116 46 Stockholm
	Sweden
telephone	+46 8 702 0360
fax	+46 8 702 0363
email	johanna@skarp.se
website	www.skarp.se

Pelle Bergström was born in 1956 in Malmö, Sweden. He studied photography at the Graphical Institute and then at Konstfack, Sweden's main school of art. He worked as a documentary photographer for some years before spending the last seven years as a stills photographer with his own Stockholm studio. Pelle Bergström's world-class clients include Hermes, Virgin Cola, IKEA and Wallpaper* magazine.

photographer	Joost Berndes
address	Voorjaarsweg 6
	7532 SH Enschede
	The Netherlands
telephone	+31 53 461 3600
fax	+31 53 461 3013
email	joost@fraterman-berndes.com
website	www.fraterman-berndes.com

Joost Berndes is 37 and started photography as a hobby at the age of about 12 or 13. He soon got addicted and following school went to art school – the School for Photography in The Hague. He developed his skills further during a period as an assistant in Amsterdam with English still photographer Martin Woods. 'About 12 years ago I started a studio together with the very good car and location photographer Ebo Fraterman. We still work together in a nice and fully equipped studio in the east part of The Netherlands and are working for various national and international clients in several fields. A glimpse of our work is shown on our website.'

photographer	Gerrit Buntrock
address	1 Warple Mews
	Warple Way
	London W3 0RF
	England
telephone	+44 (0)20 8749 1797
fax	+44 (0)20 8742 9873
email	gerrit@gbuntrock.free-online.co.uk
website	www.contactacreative.com/gerritbuntroc

Gerrit, having lived in Italy and Luxembourg, came to the UK in 1979 to study Photographic Sciences at the Polytechnic of Central London. Whilst providing an excellent technical training, the course did not particularly stimulate creativity, so, to learn a creative approach to commercial work, Gerrit worked as assistant to veteran photographer Anthony Blake, who specialised in people and food – one of the first photographers to use a food stylist. Gerrit organised many photoshoots, including assignments from Miami to New York, Sydney, Paris and Tuscany. After three years of assisting, Gerrit became freelance, working initially for editorial clients and later for design groups, mostly for food packaging and advertising. In spring 2000 Gerrit bought two studios in west London, one set up for daylight shooting, the other for blackout, both with fully-equipped professional kitchens. These are for his own use but are also being let to other food, still-life and people photographers. Gerrit's work is syndicated worldwide by four picture libraries. An increasing amount of stock material is being submitted in digital form and, although Gerrit is enthusiastic about digital capture, he is particularly excited about the possibilities that have opened up through retouching his own images.

photographer	Jean Cazals
address	27 Barlby Road
	London W10 6AN
	England
telephone	+44 (0)20 7912 1259
fax	+44 (0)20 7912 1260
mobile	+44 (0)860 777143
email	jean@cazals.fsnet.co.uk
website	www.specialphotographers-agency.com

'I like a graphic quality and construction in my pictures. Whether it's a food or travel shot – the crop is crucial. Otherwise the props, the colour, the spacing, the light etc. are also important. Basically the thing which makes the difference is each individual vision (hopefully without plagiarism). The main thing is to enjoy it and follow your line without too many compromises.'

photographer	Jay Corbett
address	Jay Corbett Studio
	7 Little W.12th St. #205C
	New York
	NY 10014-1393
	USA
telephone	+1 (212) 366 1166
email	jay@jaycorbett.com
website	www.jaycorbett.com

Jay Corbett is a New York City-based fine art/commercial photographer who creates a world of exquisitely crafted still-lifes. His assemblages have an elegant formality in which lighting, film, painting, digital enhancement and xerography all make contributions. Corbett received a BFA from Rochester Institute of Technology in 1990 after studying Fine Art in Miami, Florida. His work has been included in many shows and private collections: AGFA Photo Gallery; Communication Arts Award; Ernest Haas /Golden Light Awards; HOW Self Promotion Awards; Photo District News/Nikon Awards; PDN/PIX Digital Annual Awards; the E3 Gallery and the Visual Club Exhibition are just a few. Corbett has also been commissioned by such clients as Alitalia Airlines, AT&T, Camel, Coca-Cola, Dupont, Guinness, Charles Schwab, Eastman Kodak, Money magazine, Omni magazine, the Equitable, Turner Movie Classics and CIO Communications to create his unique form of imagery for them.

photographer	Patrice de Villiers
address	Top Floor
	5 Surrey Square
	London SE17 2JU
	England
telephone	+44 (0)20 7701 9222
fax	+44 (0)20 7701 4888
email	patrice@delicious-pdev.demon.co.uk
website	www.trayler.co.uk

Patrice de Villiers assisted full-time after taking a degree in photography. Having worked in all aspects of photography, she decided to specialise in food and still life full-time. She is now working for mainly editorial and advertising clients, shooting large format in the studio and shooting on a Yashica camera for personal landscape work. Her most auspicious award to date is Sandwich Photographer of the Year, two years running.

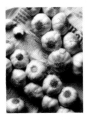

photographer	Lee Frost
address	340 Eastfield Road
	Peterborough PE1 4RD
	England
telephone	+44 (0)1733 312266
fax	+44 (0)1733 312266
email	mail@leefrost.demon.co.uk

Lee Frost picked up a camera for the first time at the age of 15 and has been obsessed with photography ever since. A former editor of Photo Answers magazine and assistant editor of Practical Photography, he was tempted by the freelance life at the age of 25, and over the last decade has established himself as one of the UK's most prolific writers on photographic technique, with a string of successful books to his name including the best-selling Taking Pictures for Profit and The A–Z of Creative Photography. When he's not writing about photography you'll find Lee behind a camera, shooting everything from food and finance to landscapes and travel. His work is represented by Images Colour Library, the Robert Harding Picture Library and the National Trust Photographic Library. He is also a sought-after photographic tutor, and leads workshops both in the UK and overseas.

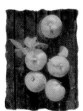

photographer	Kathleen Harcom
address	Forest View
	Furzey Lodge
	Beaulieu
	Hants SO42 7WB
	England
telephone	+44 (0)1590 612304
email	harcom_family@compuserve.com

Kathleen Harcom is a Fellow of the Royal Photographic Society and an Arena member. She is a black & white photography specialist who prints all her own work, using traditional chemical processes and fibre-based prints. Working intuitively and with a sensitive eye for light, she mainly uses infrared film aiming to capture images of a delicate quality with a 'magical' feel. Often her work is lith-printed, toned or hand-coloured to emphasise the mood she wishes to portray. Kathleen Harcom has had work exhibited in national and international exhibitions and has been published in many magazines, as well as books by Creative Monochrome and the Pro-Lighting series by RotoVision.

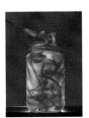

photographer	Neville Kuypers
address	10 Windle Court
	Neston
	South Wirral CH64 3UH
	England
telephone	+44 (0)151 336 8882
fax	+44 (0)151 336 8371
email	photography@bigcheese.co.uk
website	www.bigcheese.co.uk

Neville Kuypers FBIPP is one of the UK's leading exponents of food photography, with over 30 years of experience in this specialist subject. A skilful and highly respected professional, Neville is a long-standing Fellow of the British Institute of Professional Photography and also serves on their Admissions and Qualifications Board. He combines a wealth of skills and technical knowledge with a love of food and a passion for photography. Many of the techniques and lighting methods which Neville has devised over the years have been successfully employed and developed by others. He is well-known within the industry for lecturing on food photography; he is not only keen to share his knowledge but also to continue to expand his own experience, a fact highlighted by his recent transition from film to digital image capture.

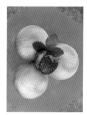

photographer	Terry McCormick
address	Basement Studio 2
	Panther House
	38 Mount Pleasant
	London WC1X 0AP
	England
telephone	+44 (0)20 7837 5115
fax	+44 (0)20 7278 9074
mobile	+44 (0)7860 555868
email	terrencejmc@cs.com
website	www.contact-me.net/terrymccormick
	www.internationalphotonet.co.uk

Terry was born in Kenya and brought up in Zimbabwe. After leaving school he pursued a career in aviation flying helicopters, and it was while on contract in the Sultanate of Oman that his interest in photography developed. He came to London, and after a short spell of assisting work set up a commercial studio where he has been based for the last 15 years. He started out working on catalogues: Habitat; Mothercare; Argos; Marks & Spencer, and thanks to his passion for cooking, has specialised in food and drink photography. Recent clients include Burger King, Somerfield, Waitrose, Budgens, Dolmio, Uncle Ben's, Guinness, Stella Artois, Croft Port and Archers. He shoots mainly on 10 x 8 inch and is seriously looking at the digital alternative.

photographer	Peter O'Keefe
address	Titchfield Studios Ltd.
	23 Mitchell Close
	Segensworth East
	Fareham
	Hampshire PO15 5SE
	England
telephone	+44 (0)1489 582925
fax	+44 (0)1489 885107
email	titchfieldstudios@btinternet.com

Peter O'Keefe is a highly-skilled commercial, industrial and advertising photographer. A Fellow of the British Institute of Professional Photography, and a member of the Association of Photographers, Peter originally trained at art college as a technical illustrator and eventually turned to photography after a short spell in graphic design. Consequently a strong graphic quality is evident in much of his photography. Working mainly in his studio near Southampton, his sense of design is complemented with many special-effects techniques employing both conventional and now digital methods. Paying close attention to detail while pushing at the boundaries of creativity has lead Peter to win many clients and awards. He works for agencies and client companies in the south of England – primarily electronics-based businesses and drinks-marketing companies.

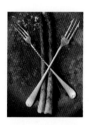

photographer	Karen Parker
address	87 Wolverton Road
	Stony Stratford
	Milton Keynes MK11 1EH
	England
telephone	+44 (0)1908 566366
email	karen@karenparker.co.uk
website	www.karenparker.co.uk
	www.karenparker.net

Karen Parker, UK Digital Photographer of the Year 2000/2001, provides a service that is unique in the UK. She has won many portrait awards, including a prestigious Kodak Gold Award, and these signify the creativity she strives for in both her commercial and personal portrait work. Specialising in portraiture and working regularly from concept to shoot, including retouching, means she's regularly in demand from a diverse range of businesses. However, Karen is also at the forefront of technology as she's recently invested in a digital back, which allows the client to view results within seconds and/or email them during a shoot. In a real emergency, studio shoots can even take place at any hour. This level of service means everything is in-house and very personal – or, as Karen puts it, 'Maybe it's time to believe the hype.'

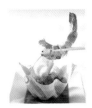

photographer	Steve Payne
address	H.M.D. Photographic Studios
	The Old Forge Works
	Chase Side
	Southgate
	London N14 5PJ
	England
telephone	+44 (0)20 8886 0181
fax	+44 (0)20 8886 3524
email	stevehmdphoto@aol.com
website	www.contact-me.net/stevepayne

Based in north London, Steve's studio is about 800 square metres, with extensive kitchen facilities and a large selection of props, backgrounds etc. He specialises in food photography covering the areas of advertising, packaging and marketing and PR work, working for design agencies and direct for food retailers within and outside the UK. Steve has 20 years experience photographing food. 'I use Sinar 10 x 8 inch cameras along with Broncolor lighting, however over the past 18 months a large percentage of my work has been shot digitally using the Sinar back. I have been converted! – something unimaginable three years ago. No matter what type of relationship you have with your clients, I always adopt the attitude that every project, no matter how large or small, must have my full commitment. I pay attention to every last detail, from product awareness to lighting and composition, while always fulfilling very tight briefs. I treat every piece of work as though it is my first for a client, as in the business of food photography you are only remembered for your last assignment.'

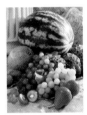

photographer	Cicero Viegas
address	R. Daniele Crespi 94
	São Paulo
	05527–010
	Brazil
telephone	+55 11 5096 1098
email	viegasph@terra.com.br
website	www.viegasphoto.com.br

Cicero Viegas was born in Brazil in 1948 and he has worked in São Paulo since 1968. He has had his own studio since 1980, specialising in food photography for advertising, magazines, and publicity agencies. He has also taken pictures for 12 books, four of them were about Brazilian food and the others were Japanese, Chinese, German, Arabian, Spanish, French, Italian and Portuguese food. His two main passions are food and nature photography.

photographer	Jeremy Webb
address	The Shambles
	55 Caernarvon Road
	Norwich NR2 3HZ
	England
telephone	+44 (0)1603 610753
mobile	+44 (0)7947 105451
email	jeremywebb.photo@virgin.net
website	www.picassomio.com/JeremyWebb/
	www.arteutile.net/webb/
	www.noble-art.co.uk/artists/jeremy_webb/

Jeremy graduated from the Berkshire College of Art and Design in 1984, and has been a practising freelance photographer ever since. His photography has taken him on assignments to Europe, and more recently as an expedition photographer in Tanzania and a cruise-ship photographer based in Florida, USA. 'I currently combine a variety of teaching appointments with my commercial work, while trying to find the time and funds to continue working on my own personal work for future publication and exhibition projects. I'm continually experimenting with combining new digital technology with traditional photography.'

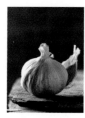

photographer Paul Webster
address 2C Macfarlane Road
 London W12 7JY
 England
telephone +44 (0)20 8749 0264
fax +44 (0)20 8740 8873
email paulsnap@dircon.co.uk
websites www.paulsnap.dircon.co.uk
 www.p-anton.dircon.co.uk

Paul Webster is an internationally renowned food and drink photographer based centrally in Shepherds Bush, London. He has a fully-equipped digital and traditional studio with a modern kitchen. Paul has the equipment and skills for shooting, manipulating and scanning high-resolution digital work, which can be sent via ISDN to his clients. Alongside Paul's studio is China & Company, one of London's premier props hire companies for everything related to food and drink – from plates to surfaces. Paul's clients include Waitrose, Sainsbury's, Safeway, Marks & Spencer, Somerfield, Tesco and many other UK and European food manufacturers and retailers. He always relishes a challenge.

photographer Francesca Yorke
address 23 Buller Road
 London NW10 5BS
 England
telephone +44 (0)20 8964 2808
email francescayorke@hotmail.com

Principally a location photographer, Francesca Yorke tackles an impressive range of subjects with a reportage slant. 'I begin with the bare minimum,' she says, 'using mainly available light and only adding further lighting if it's necessary.' In addition to food, she shoots travel, gardens and flowers, still life, architecture, interiors, portraits and lifestyle for editorial as well as for company reports and brochures. A graduate of Central St Martin's School of Art and Design and the London College of Printing, her work is regularly seen in publications including the Independent on Sunday, Gardens Illustrated, Waitrose Food Illustrated, Harpers & Queen, and You magazine. She has illustrated many cookbooks for leading publishers, including Nigella Bites for Chatto & Windus, as well as gardening books such as Urban Eden and Planted Junk. Francesca tries to escape London in the winter to travel and has completed a number of Dorling Kindersley travel guides.

would you like to see your images in future books?

If you would like your work to be considered for inclusion in future books, please write to: The Editor, Lighting For..., RotoVision SA, Sheridan House, 112/116A Western Road, Hove, East Sussex BN3 1DD, UK. Please do not send images either with the initial inquiry or with any subsequent correspondence, unless requested. Unsolicited pictures may not always be returned. When a book is planned which corresponds with your particular area(s) of expertise, we will contact you.

acknowledgements

Thanks must go, first and foremost, to all of the photographers whose work is featured in this book, and their generosity of spirit in being willing to share their knowledge and experience with other photographers. Thanks also to those companies which were kind enough to make available photographs of their products to illustrate some of the technical sections. Finally, enormous thanks must go to the talented team at RotoVision, including Commissioning Editor Kate Noël-Paton and Assistant Editor Erica Ffrench; to Ed Templeton and Hamish Makgill from Red Design for their stylish layout; and to Sam Proud for his clear and elegant illustrations.